CM0074001110

"Illustration is the last bit of the creative process—it's the fat kid with the glasses who gets picked last, but when you're treated right it's marvellous. You just need to work with the right art director; someone who understands. There are worse things to do."
Paul Davis

"Illustration is a form of escapism and it's also the best job in the world!"
Marine

"Illustration is a means of crossing language barriers and sharing emotions."
Steve Lawler

"Ilustration is sucking something up with your eyes and spitting it out of the end of a pencil, pen, brush, nozzle, or cursor …"
JAKe

"Being paid to draw and think is fantastic."
Nigel Robinson

"Illustration is all about ideas, and the start of a wonderful thing."
NEW

"Illustration is the cherry on the tart. It's the icing on the cake. It's the sprinkles on the donut."
Jawa and Midwich

RotoVision

A RotoVision Book

Published and distributed by RotoVision SA
Route Suisse 9
CH-1295 Mies
Switzerland

RotoVision SA
Sales and Editorial Office
Sheridan House, 114 Western Road
Hove BN3 1DD, UK

Tel: +44 (0)1273 72 72 68
Fax: +44 (0)1273 72 72 69
www.rotovision.com

10 9 8 7 6 5 4 3 2 1

ISBN: 978-2-88893-033-4

Art Director for RotoVision: Tony Seddon
Design: JC Lanaway
Typeset in Univers and Akzidenz

Reprographics in Singapore by ProVision Pte.
Tel: +65 6334 7720
Fax: +65 6334 7721

Printing and binding in Singapore by Star Standard Industries (Pte) Ltd.

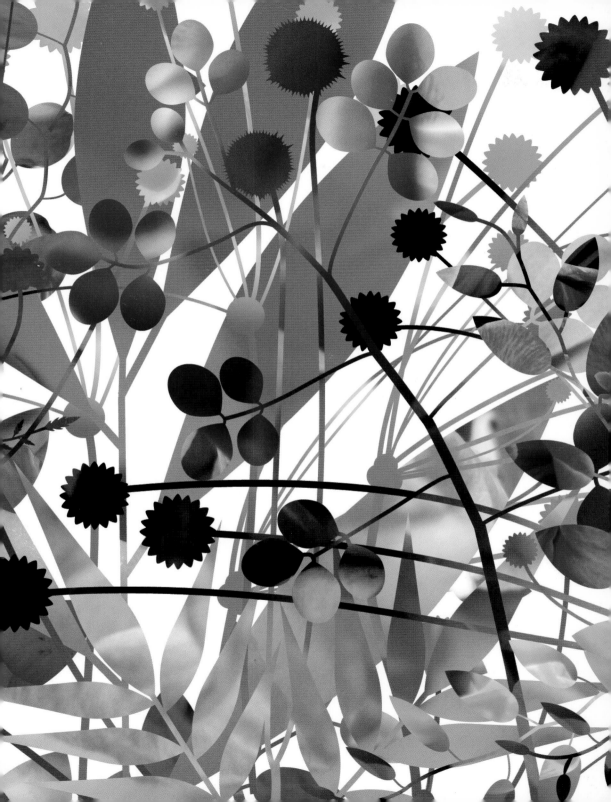

Issues

Anatomy

Portfolios

Etcetera

What is illustration?

Illustration isn't straightforward. It isn't easy to describe or to classify, to typecast or to pin down, and less so now than ever before. Illustration isn't art and it isn't graphic design, so what exactly is it?

As a discipline, illustration sits somewhere between art and graphic design. Of course, for many practitioners it can feel closer to one end of this spectrum than the other, but in the search for an all-embracing descriptive term, illustration is frequently referred to as a graphic art.

Another term often used to describe the discipline is commercial art, in recognition of the fact that much illustration is created for a client to fulfill a task or brief. This term describes illustration that is less about personal expression and more about satisfying a service, but to consider the discipline in this superficial manner is to barely scratch at the surface. It does not look deep enough into the working methods and ideologies of contemporary practice to extract a true understanding of illustration.

The first marks made by humankind were probably drawn in the dirt with a finger or a stick. Alongside speech, the drawn image has played a vital role in communication between people, and before the development of written language it was the only method of recording stories and tales. Illustration came into existence to help us make sense of our world—to allow us to record, describe, and communicate the intricacies of life.

Today's illustrators have an even more complex set of tasks. They seek to combine personal expression with pictorial representation in order to convey complex ideas and messages. Illustrators are required not only to communicate, persuade, inform, educate, and entertain, but also to achieve this with clarity, vision, style, and often from a personal standpoint.

Illustration remains one of the most direct forms of visual communication. However, as one element in the broad field of modern visual communications, illustration has never been more diverse or disjointed; it is constantly crossing boundaries between disciplines and breaking with traditions. Illustrators create images for print, for screen, for galleries, and for architectural spaces. Illustration appears on book jackets and in magazines, on CD sleeves and posters, on websites, on clothing, on skateboard decks, and on TV.

While illustration can be applied to an ever-increasing range of surfaces, and the landscape of possibilities is constantly changing, the concern for contemporary illustration is to resist classification, to surprise its audience, and to remain true to the concept that illustration is anything but straightforward.

CD cover
Pen, paint, gold leaf, collage
Los Angeles–based band Live From Little Tokyo commissioned Alison Casson to create this image for a magazine that accompanied the CD release of *Love is That Way, You Try It, You Like It; You Buy It*. Casson combined found images with her own hand-drawn elements in this stylistically diverse promotional illustration.

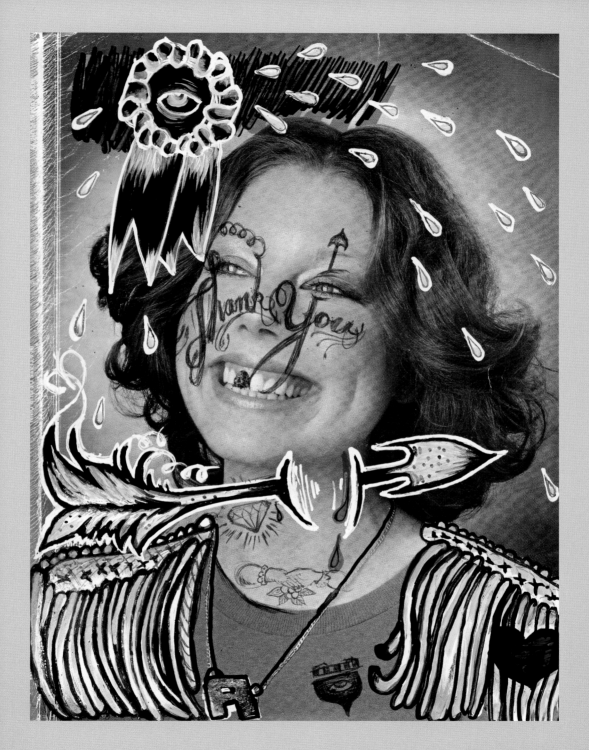

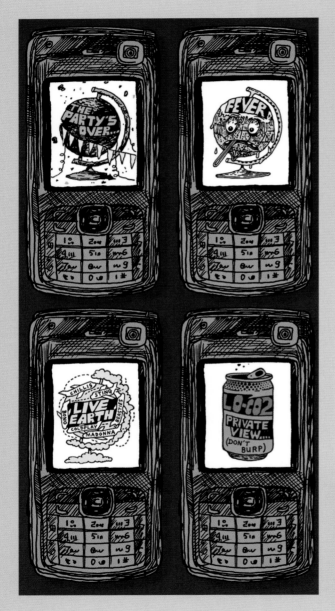

Picture message
Pen, digital
Mobile network Virgin Mobile UK commissioned Jody Barton to create a series of images for an exhibition entitled Low CO2. These were distributed as picture messages to promote the reduction of carbon emissions. Barton's approach combined bold, graphic drawing with succinct, yet powerful messages.

T-shirt and tote bag
Digital
This image, designed as a graphic for T-Shirts and tote bags, was created by Adrian Johnson for Part of It, an organization set up by Christopher Sleboda and Kathleen Burns of Gluekit to create products for charitable causes. Johnson chose to support the World Wildlife Fund with sales from the two products.

Print ad
Pen and ink, digital
Robert Hanson's work for
Orange Exchange magazine
combines a strong creative
concept with simple and
stylish image-making.
It provides a succinct
communication of the
functionality of mobile
e-mails for businesses.

Screen-printed cards
Digital, screen print
Simon Dovar of Simple Shape,
and one half of illustration and
design duo Jawa and Midwich,
created Common British
Garden Birds, a limited-
edition set of screen-printed
cards. This simple, four-color
print depicts a giant bird
attacking a British milk float
(an electric vehicle).

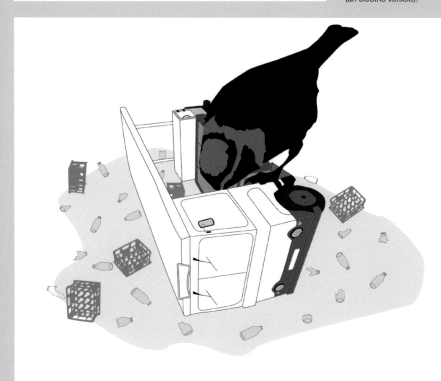

What is an illustrator?

Classifying the role of the illustrator is as problematic as defining the discipline of illustration. Practitioners rarely operate solely as illustrators; their practice will often merge with territory chiefly inhabited by artists, designers, craftspeople, and even writers. Illustrators blur boundaries and revel in defying categorization; illustrators often work across a range of disciplines, utilizing varied media.

So what is it that defines today's illustrator? Unlike the photographer, the illustrator can make no claim to sole use of the camera; unlike the graphic designer, the illustrator can't assert ownership of typography, nor can they claim the print screen or the paintbrush as their own. In today's merging media landscape, many illustrators pick and choose their medium or media of expression. Drawing, while still an important aspect of illustration, has become just one component of the illustrator's craft: digital photography, collage, hand-rendered type, stencils, pattern, and ornamentation all fight for recognition. It is this inherent flexibility in working methods, styles, and approaches that ensures the illustrator eludes formal classification.

Whether working solo, represented by an agency, as part of a collective, or as part of the emerging scene of illustration companies, illustrators are commissioned by a range of clients outside their working space. An illustrator might choose to work from a desk in a shared, city-center studio; to use a spare room in an apartment or house; or to locate themselves in a summer-house or shed at the bottom of their garden. An illustrator is free to locate their physical space according to their creative needs and requirements rather than proximity to their client base. As illustrators rarely host client meetings, and as most business communication is conducted by e-mail and phone, they find themselves free to work without formal constraints. Having studio location determined by lifestyle choice rather than geographic necessity allows the illustrator to operate at a distance from the rest of the creative industry. With illustrators rarely having to clock into the nine-to-five existence of much of the working world, they can enjoy a certain level of freedom from the pressures to conform.

An illustrator's immediate client is most often the designer or art director of a design studio, publishing house, or advertising agency; the client is rarely outside the creative industries. The illustrator is able to work for and with the creative industry, yet remain an outsider, participating when commissioned, attending briefings and meetings, yet retreating to the studio when artistically necessary. This working lifestyle is a contributing factor to the stereotype of the illustrator as an artistic loner.

Fashion promotion
Digital
Ayşegül Özmen, based in Istanbul, Turkey, works with her own photographs, patterns, and hand-rendered images to create atmospheric solutions. This illustration was commissioned for the promotion of a spring/summer collection by fashion company, Misu.

Successful illustrators must marry excellence in practical skills with imagination and intellectual rigor. They must be culturally and socially aware practitioners and commentators. Just as important, they must learn to exist in their own space at the edge of the creative industries, without the support mechanisms of the nine-to-five existence. Today's illustrators must be self-motivated, ambitious, flexible, and innovative visual communicators.

Left:
Self-portrait
Digital
Designer-turned-illustrator Richard Hogg describes himself as a commercial artist. This self-portrait was created for use on his business cards, as an opening image for his portfolio, and for display on his agent's website.

Top right:
Magazine feature
Photograph, pen and pencil, collage
Paris-based Sandrine Pagnoux revels in merging photography, drawing, and hand-rendered letterforms. In this image for *Marie-Claire* magazine she explored the theme of men and love.

Bottom right:
Book illustration
Mixed media, collage
Martin O'Neill of Cutitout illustrated a special edition of *On Liberty* by John Stuart Mill for The Folio Society. This one-off project included illustrating the book case and binding, and creating 11 full-color illustrations to be printed within the book. O'Neill's collage techniques, while decidedly low-fi, have helped him to carve his own niche in an overcrowded illustration market.

Above:
Magazine feature
Digital
Blanket magazine dedicated
one issue to the theme
"I Made This." Daniel Stolle,
a German designer-turned-
illustrator now working out
of Finland, explored the
concept of a picture within
a picture, and the idea that
you are personally influenced
by your own creations.

Left:
Exhibition image
Pen, spray paint, digital
Roderick Mills works as
an illustrator, animator, and
educator. He often experiments
with new formats and working
methods in his own projects.

Right:
Film festival promotion
Pen and ink, digital
Barcelona-based Oscar
Gimenez created Headbang
to promote the Mecal
International Short Film
Festival held in the city.

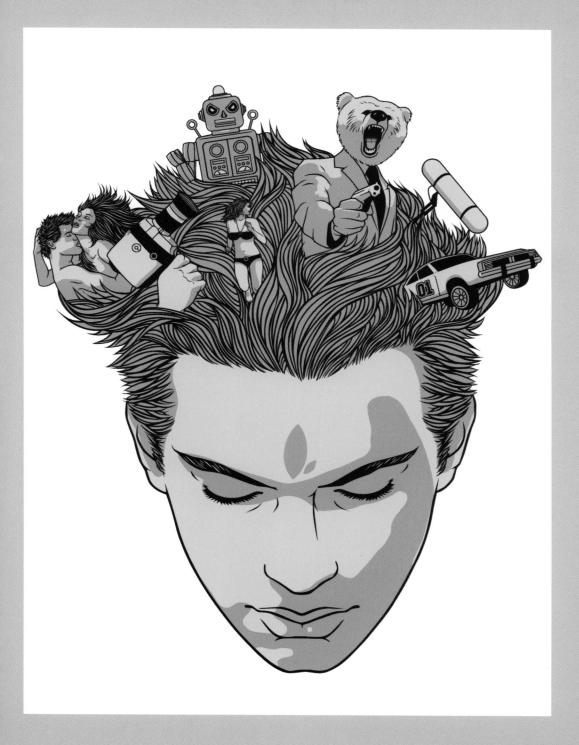

A brief history

Illustration's history is a story rarely told. For whatever reason, the "people's art," a term coined by the US art director and design writer Steven Heller, has received no genuine historical acknowledgment on its own—it appears as a sideline in graphic design's past or a footnote in the history of art itself.

It could be argued that European cave paintings and Australian Aboriginal rock art dating back 40,000 to 60,000 years, Egyptian hieroglyphs from around 3,000 BC, the murals of Pompeii painted around the first century AD, fourteenth-century illuminated manuscripts, and Italian frescoes, enjoying a golden age during the fifteenth century, should all be considered part of illustration's past rather than belonging to the history of art. But this would be to ignore the place of illustration within art history.

Before the birth of modern art, artists created paintings with the intention of telling a story or communicating a particular message, and most representational art was intrinsically linked with literature and its visual interpretation. For almost seven centuries, artists were commissioned to create images that explained religious texts, legends, and myths, as well as local and national historical events. The artist would work to specific formats and within certain outlined contexts, with many images being produced to accompany letterforms and texts. This is not so radically different from the role of today's illustrator.

The biggest shift for artists involved the change in those who commissioned them. With the birth of the publishing industry in the nineteenth century, publishing houses replaced the traditional patrons of the arts,

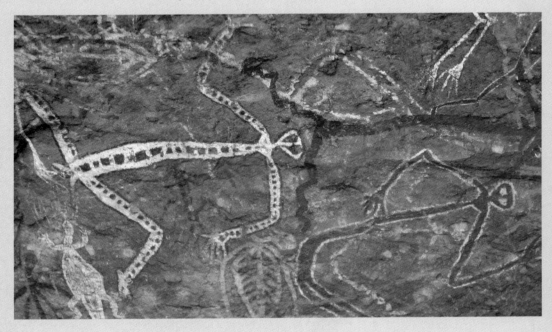

the church and court, as the chief employers of artists. Publications became a hugely influential showcase for their work, and illustration, a product of the industrial revolution, became a significant area of interest for artists.

A golden age of illustration emerged as illustrators assumed an importance hard to imagine today. At the end of the nineteenth century, publications and the illustrations within were the general public's major source of entertainment, and this continued through the first decades of the twentieth century. The illustrator became a cultural commentator. The publications they worked for had a major impact on the public's understanding of national and international events, and on its taste, morals, humor, and purchasing habits.

Below, far left:
Rock art
Mineral paints
Part of an Aboriginal legend painted in the Anbangbang Shelter. The walls of the Nourlangie Rock Art Site in Australia's Northern Territory have served as a canvas for at least 20,000 years, with its visual stories painted over and added to throughout this time. Repainting is part of the rock-art tradition, although not all rock art was repainted, and only people who were authorized or recognized as artists were allowed to repaint. The Anbangbang Shelter drawings were last worked on in 1964.

Below left:
Magazine feature
Gouache
Included in a 1938 issue of the radical American magazine *Ken*, this map uses cartoon-style illustration to warn against Hitler's ambitions and notions of empire building.

Below:
Magazine ad
Oil paint
American advertisement from 1948 for bread by Swift & Co.

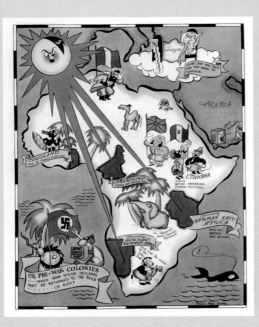

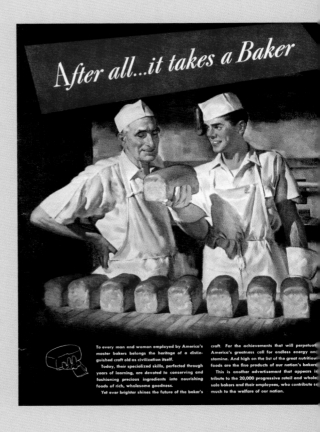

The proliferation of newspaper and magazine publishing was accompanied by a noticeable increase in print advertising, and this required the expertise of the illustrator. From magazines and newspapers to the first illustrated posters, and from illustrated books and book jackets to the birth of the record sleeve, illustration has been at the heart of the graphic image.

The National Museum of American Illustration in Rhode Island, USA, argues that the discipline plays an important and lasting role. "Illustration serves as a reservoir of our social and cultural history." Illustrated images capture the imagination—they tie moments in a viewer's personal history to the present, from our favorite childhood book to the album sleeves and posters of our youth.

Illustration has played a part in visually defining each and every decade since its inception. Its history is littered with iconic images, bringing moments, events, music, and literature to life. To borrow the words of The National Museum of American Illustration again, "Illustration is a significant and enduring art-form."

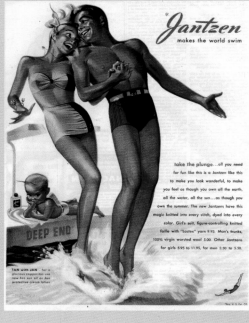

Above right:
Magazine ad
Gouache
American advertisement from June 1947 for Jantzen swimwear.

Right:
Magazine ad
Gouache
Advertisement from 1954 for American Airlines.

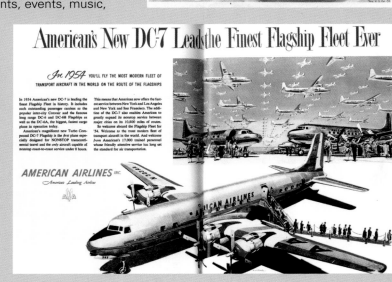

Below:
Promotional poster
Screen print
Helena Fruehauf created this poster to publicize lectures by visiting artists at the California Institute of the Arts. This one was to promote Richard Jackson's visit in 2001. The idea behind the design was to emphasize the role of movement, repetition, and distortion in his work.

Bottom:
In-flight magazine
Pen and ink
Carlos (published by John Brown) is Virgin Atlantic's in-flight magazine for its Upper Class cabin passengers. For this 2004 issue, the brief for creative director Jeremy Leslie and art director Warren Jackson was to "reflect Virgin Atlantic's philosophy of innovation."

Below:
Encyclopedia
Wood engraving
A plate from the first picture encyclopedia for children. This edition of *Orbis Pictures*, by John Amos Comenius, was printed in England in 1659.

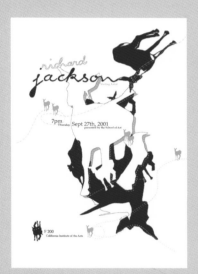

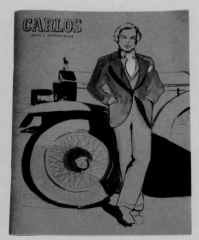

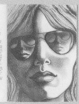

Commercial art

Illustration is an applied art. It is most often created for a commercial client in response to a given brief or texts. Of course, there are exceptions to the rules and, increasingly, illustrators are starting their own projects: self-authored books, 'zines, exhibitions, clothing ranges, etc. However, their main occupation is working to commission for a range of clients across the media industries, and working commercially requires an understanding of the issues and principles of the commission.

Every illustration commission starts with a brief and a briefing. This may be a conversation face-to-face or on the phone; it may be an e-mail that specifies a theme, format, deadline, and fee; or it may be an article or manuscript. The format of the commission might alter, but the underlying process of working to commission will not.

Answering the brief involves investigation. Illustration has a job to do, whether this be to educate, inform, entertain or persuade, give an opinion, make a comment, or tell a story. The initial stages of any commission deal with comprehending the problem, understanding the context of the illustration, and identifying the audience.

Once the issues raised are understood, the process of solving the brief can be broken down into its component parts, starting with brainstorming and ideas generation, moving on through research and inspiration to the creation of the visual and subsequent revisions, and ultimately to the realization of the final artwork.

It is a journey not without minefields. Miss the point of the brief, or fail to communicate succinctly, and the project can, at best, be delayed and, at worst, canceled. This decision is one that rests not with the illustrator, but with the client. A key factor in the relationship between the commissioner and the commissioned, power most often rests with the former. The relationship between the client and the artist can be complex, and illustration's fundamentally commercial nature means that client comments and feedback need to be taken into account. But when the liaison and rapport work well, the association can lead to truly innovative solutions to visual communication problems.

Magazine feature
Ink, gouache, digital
Playboy magazine, Germany, commissioned Berlin-based Tina Berning to illustrate a feature about sex seminars for women. Berning's work often includes the female form, and this commission enabled her to explore ideas and techniques initiated in her personal work.

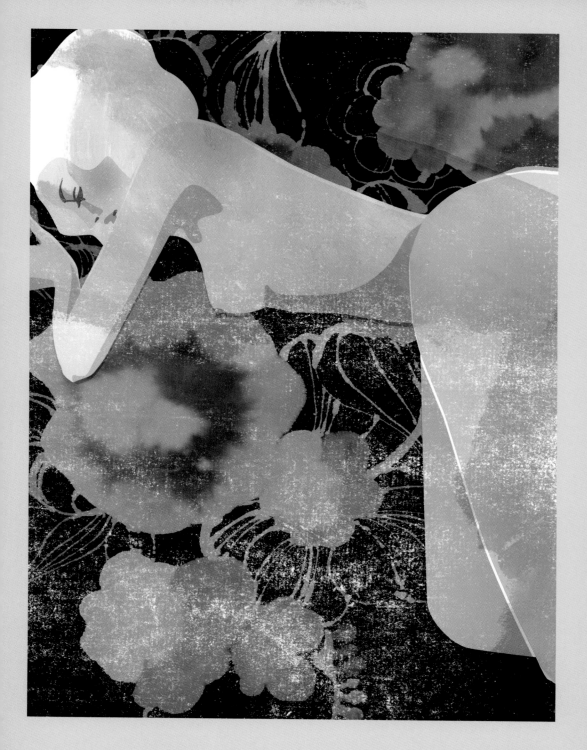

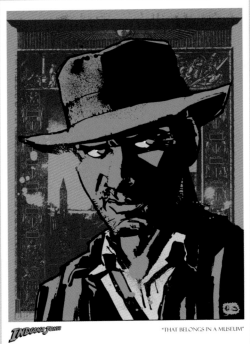

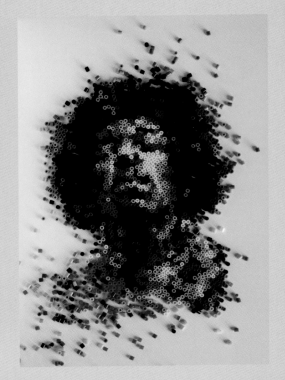

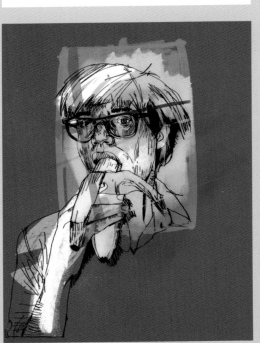

Above left:
Anniversary print
Lithographic print
JAKe was commissioned by Lucasfilm Ltd/Acme Archives to produce a limited-edition lithographic print of Indiana Jones. *That Belongs in a Museum* was printed using three Pantone metallic inks; JAKe's original drawing was created using pen, pencil, marker pen, spray paint, and Adobe Illustrator.

Left:
Magazine illustration
Screen print, pencil, paint
For *Time Out* Paris, Patrick Morgan used Andy Warhol's favorite medium—screen print—combined with pencil and paint, to create this portrait of modern art's most commercial artist. Bringing a pop sensibility to the portrait while remaining true to his own identity as an illustrator was a challenge for Morgan.

Above:
3D illustration
Mixed media, beads
London-born but New York–based Ian Wright, well recognized for his innovative use of materials, created this iconic image of Jimi Hendrix for If You Could Do Anything Tomorrow, What Would It Be? Wright has described himself as a "painter and decorator."

Right:
Fashion ad
Pen, digital
For urban fashion label Carhartt Europe, NEW designed a full-page magazine illustration using an artwork constructed by overlaying and overprinting drawings taken from the studio's sketchbooks. These seemingly unrelated drawings created a unique campaign that gave the Carhartt brand a cool, graffiti-inspired edge.

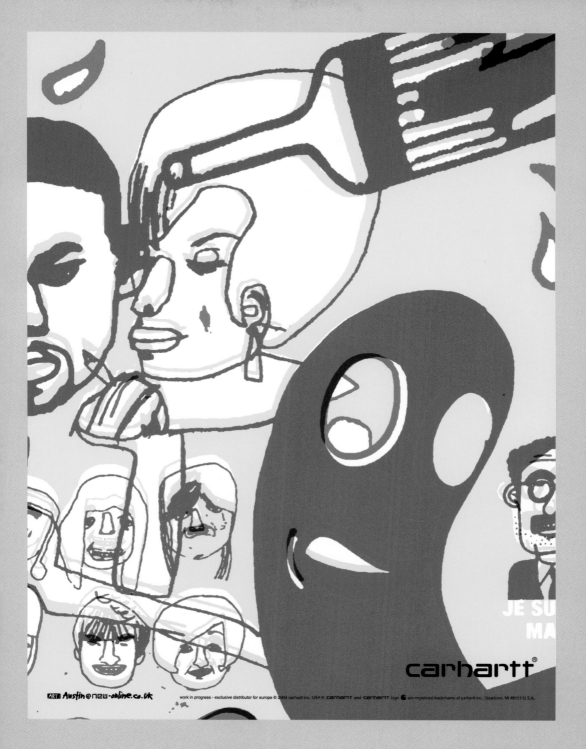

Reading visual images

Illustration has been described as the people's art—accessible and available to all. The relationship between viewers and illustration develops throughout their lives. Illustrations can create emotional bonds between viewers and moments in their lives, although illustrators rarely understand the intellectual underpinning of their chosen images; more often, they know instinctively that a particular image choice works and communicates the right message. Illustrators work with a hunch rather than an analytical science, and each individual's "visual history" will influence their response to an image. However, semiotics, the study of how we interpret images and text, helps us to understand how societies "read" images.

We learn to decode images from an early age. Children's picture books play a formative role in our visual education through the messages they carry, and the means by which that information is conveyed. When we first start to draw, we learn to make associations between visual interpretations and their real or imagined objects. We start to comprehend visual shorthand—a stick-man to represent a person, or a circle with radiating lines to signify the sun. These graphic interpretations, often culturally specific, form the basis of how we learn to interpret images.

While an in-depth knowledge of semiotics isn't necessary for most illustrators, a basic understanding of how images are perceived can help. Semiotics considers both the signs themselves and the codes or systems in which the signs are organized. It explores the range and variety of signs in existence, and the audience to which they are intended to communicate.

In illustration, signs are constructed from the icons and symbols within an image; semiotics considers the messages these generate. An icon is a graphic that bears a resemblance to the object it represents, whereas a symbol is a graphic that suggests something else through relationship, association, or convention.

Considering the context—the culture and artifact—within which icons and symbols operate is an important part of semiotics. A comic book has a look and feel that differs from an instructional manual, for example. How does an audience respond to these differences, and to what conventions must illustrators conform to ensure that they communicate the message they intend?

Of course, there are other factors that influence how a viewer perceives images. Color, composition, scale, and metaphor are all important elements. An illustrator's personal visual language is as much about his or her communication of concepts as it is about aesthetic considerations.

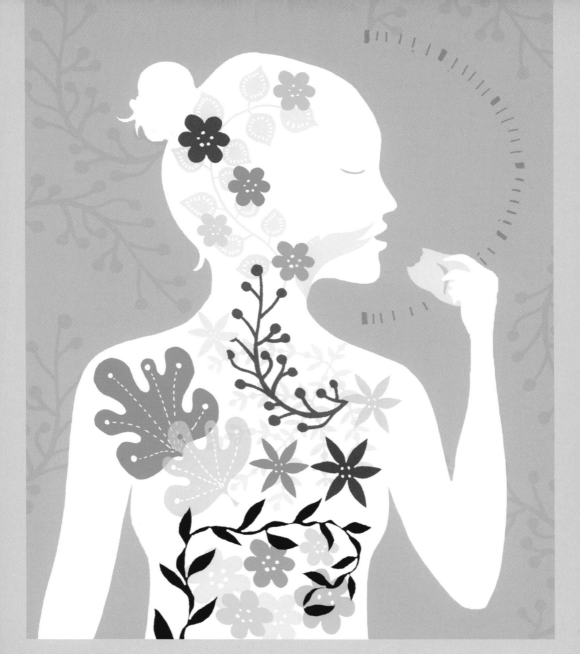

Promotional diagram
Pen, digital
To represent the benefits of healthy
eating, Alice Stevenson used floral
images to create a pattern within
the figure and suggest the positive
aspects of a "natural" diet.

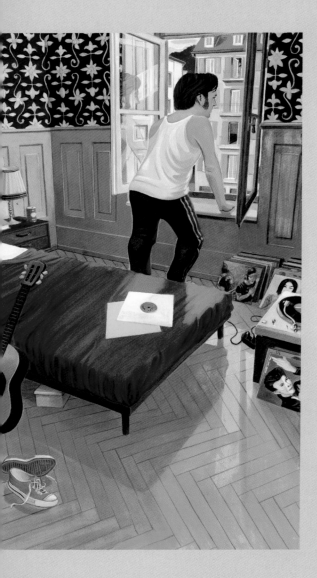

Left:
Promotional poster
Acrylic paint
Andreas Gefe, in this poster
for a CD release by Swiss
singer/songwriter Trummer,
creates a picture rich with
associations. The Björk and
Bowie album sleeves on the
floor create a timeless setting,
and the acoustic guitar gives
a sense of the artist's musical
tastes. The red of the book,
Converse shoes, and can
on the bedside table prompt
the question, "How are these
objects linked?"

Right:
Magazine cover
Digital
At first glance, this image
appears to be a foot in a
high-heeled shoe. However,
closer up, the individual
elements of Jamie Cullen's
pop-inspired graphic pattern—
shoes, feet, ankles, legs,
hearts, guitars, flowers, and
letterforms—become visible.
Pure pop.

Above:
Personal work
Digital
Junichi Tsuneoka, a Toyko-
born illustrator now residing
in Seattle, creates his work
using icons, symbols, and
signs. This is, perhaps, the
result of having worked as
a graphic designer for five
years. Tsuneoka fuses
conceptual and stylistic
aspects of Japanese pop
and US urban street cultures
in his illustrations. He created
this image under the studio
name Stubborn Sideburn,
based on his interpretation
of the Nintendo 64 games
character Ninja Goemon.
Knowledge of the game and
the character are crucial for
the audience to understand
the meanings and messages
within this picture.

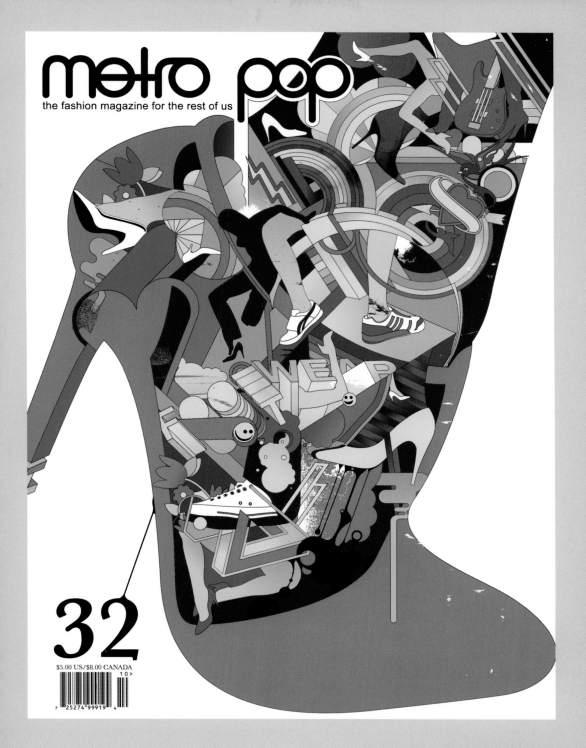

metro pop

the fashion magazine for the rest of us

32

$5.00 US/$8.00 CANADA

7 25274 99919 4

Personal visual language

It is because of the visual approach they take, the working methods they adopt, and the aesthetics they follow, that successful illustrators create a body of work with a recognizable visual identity. Establishing a personal visual language is vital for an illustrator keen to survive the whims of fashion and style, although both do have their place in illustration. The longevity of an illustrator's career is determined by how long a particular visual approach is deemed relevant to the marketplace. Many illustrators constantly update their style and approach, and some even devise a range of visual signatures to help combat this process of obsolescence.

Magazine illustration
Digital
Given an open brief from *Amelia's magazine*, Adrian Fleet created this surreal image, based on his fantasy that a positive future will allow robots to feed on electric pears that grow on rooftop gardens. His unique visual aesthetic complements his offbeat thinking.

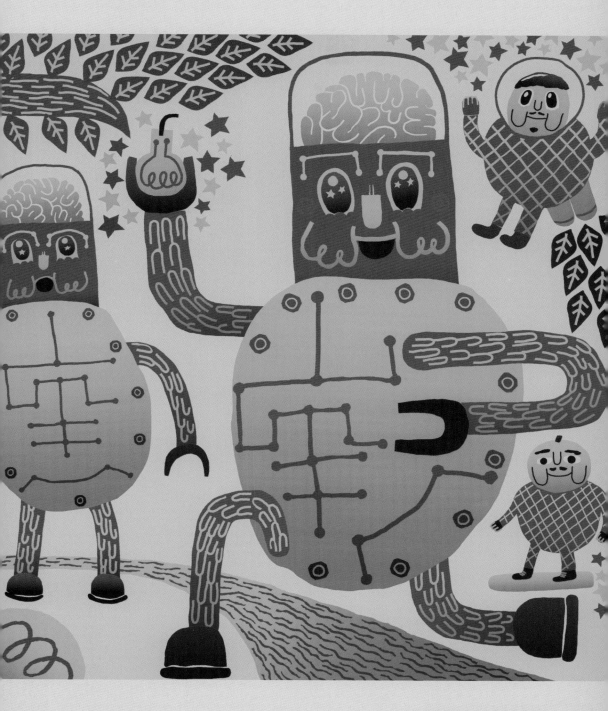

As illustration is about communicating a message, how that message is delivered is crucial. Developing a unique visual language can take many years of experimentation and fine-tuning. Seemingly simple images can belie the journey the artist has taken in honing their approach to image-making.

Many illustrators have their services called upon for the particular slant of their creative and conceptual thinking as much as for the visual signature of the work itself. It is the ability to combine creative, visual, and analytical problem-solving with personal expression that defines the innovators within contemporary illustration.

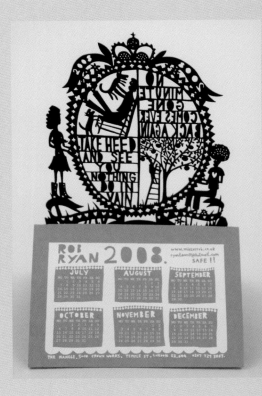

Promotional calendar
Laser-cut paper
Robert Ryan has established a unique working method using cut paper to create intricate, silhouetted images combining figures, patterns, and icons with hand-cut letterforms that spell out his own sensitive messages and phrases. This collaboration with Lasercraft, using laser-cut paper, allowed Ryan the freedom to produce a promotional calendar for his own work, as well as that of the company.

Greeting card
Digital
Simon Oxley is idokungfoo, a British-born illustrator living, working, and running his own studio in Japan. Undertaking commissioned work accounts for only part of his creative output; he has also forged a greeting card business, designing and illustrating his own ranges. Bad Hare Day/ No More Magic shows Oxley's ability to sync creative ideas with his own visual language to create characters of real depth and imagination.

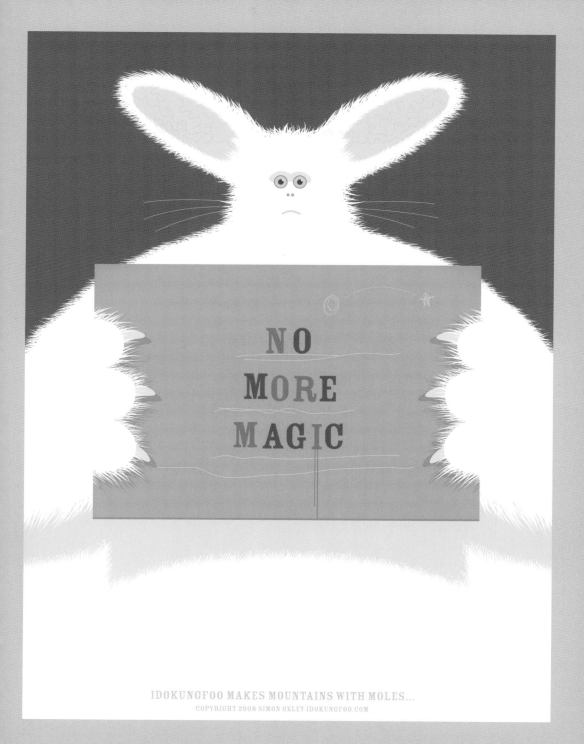

IDOKUNGFOO MAKES MOUNTAINS WITH MOLES...
COPYRIGHT 2008 SIMON OXLEY IDOKUNGFOO.COM

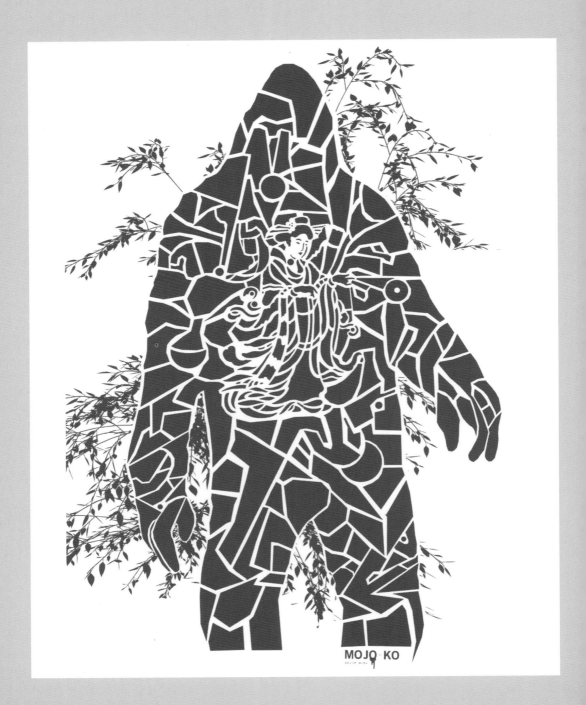

MOJO-KO

Left:
In-store poster
Digital
Steve Lawler, working under his studio name Mojo-ko, created this image for an in-store poster for retail outlet LOFT, in Singapore. He fused traditional and modern forms with his own interpretations of Japanese culture. This image is striking for its simplicity, yet is stylistically bold.

Right:
Poster campaign
Digital
Paris-based illustrator Frédéric Péault created a poster campaign for Ademe, the French environment and energy-management agency, using imagery and ideas associated with *Gulliver's Travels* and the tiny people of Lilliput.

Style over content

There will always be those who argue that content comes first and that style, or appearance, must be dictated by the creative idea—that the Bauhaus mantra "form follows function" must be obeyed without question. For those who believe that visual problem-solving is at the heart of all illustration—that illustration has a responsibility to communicate, and a job to get done—this is a hard habit to break.

However, for an ever-increasing number of younger illustrators, with a different set of aspirations and a more eclectic client base, this covers only part of the story—they are motivated more by riding the waves of fashion, style, and cool.

Until a shift in perception in the 2000s, illustration wasn't considered cool, hip, or fashionable in any way. It was very much sidelined by graphic design in the mid-1990s, with designers creating images themselves—on their new toy, the Apple Macintosh—as a means of getting around commissioning illustration. Illustration needed rethinking, rebranding—a radical overhaul: embracing digital technology and throwing out the old rulebooks helped to kick-start the process.

Top right:
Magazine feature
Digital
Marine combined photographic reference with digitally drawn shapes to produce an image as rich in style as it is in content.

Right:
Fabric design
Digital
This image, created by Steve Lawler at Mojo-ko, explores the fusion of Eastern and Western cultures. It was created for the fabric design of a laptop bag produced by Fabrix, in Singapore.

CD cover
Collage, digital
Grandpeople, a Norwegian
illustration and design studio,
created this illustration for
the CD release of *Bad Taste
Emergency* by Andrea's Kit
on LOAF Records. The work
tapped into the zeitgeist for
collaged, dreamlike images,
and captured a sense of the
music and the band.

With new ways of "drawing," new modes of expression, and new approaches to image-making, illustrators began to set a new agenda, and to offer a new perspective, an updated view of the world, and a broader skill set that designers wanted to bring back into the fold.

Illustration has learnt from its past mistakes; just as fashion and music constantly evolve, so now does illustration, with innovative working methods and cutting-edge ideas tested through underground 'zines and independent fashion magazines, avant-garde galleries, and street art. Once alienated by the design press, illustration is now written about extensively. Once ignored by art and design publishers, a new audience is being catered for with books on the subject appearing, it seems, on a monthly basis.

Illustration's rebirth has been a long time coming, but the mavericks prepared to lead rather than follow, to experiment rather than emulate—by those who believe in style over content—have secured its spot in the limelight.

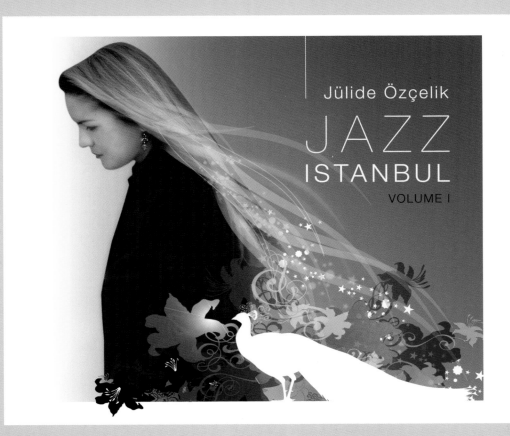

Far left:
CD cover
Digital
This visual interpretation of
Jülide Özçelik's music was
created by Ayşegül Özmen
for the release of Özçelik's
CD *Jazz Istanbul*. Özmen
combined her own photograph
of the artist with digitally
drawn elements.

Top:
Desktop wallpaper
Digital
Brazilian studio Mopa was
commissioned to create
a downloadable desktop
wallpaper by Bobby Solomon
at Kitsune Noir, a design-
related blog. Mopa's aim
was to make the computer
user happy every time they
turned on their computer.
Style-led rather than concept-
driven, the final illustration is
testament to Mopa's ability
to interpret fashions in image-
making and work them into
viable design solutions.

Center and left:
Personal work
Pencil, digital
Kai Hofmann's self-initiated
images of Berlin buildings
are stylistic interpretations
rather than realistic drawings.

Illustration vs design

Illustration's relationship with graphic design is an issue in itself; love–hate might best describe it. While in vogue, graphic design supports and courts illustration, but this love affair can be a fickle thing, with design ditching illustration for the next big thing at the drop of a hat.

Illustration stands as its own creative practice, yet also exists as an adjunct to graphic design. Both areas function independently within the discipline of visual communication. There is a bridge that links the two, but the relationship is not equal. Illustration needs graphic design on a more permanent basis than design needs illustration—the bridge can be raised and lowered, but is operated by design alone.

Graphic designers resolve communication problems through the use of typography, or the combined use of typography and image. In designing or art directing the overall look and feel of a concept, there are many who choose entirely typographic solutions, or to collaborate with a photographer rather than an illustrator. Within graphic design, the illustrated image is distinctly less common than the photographic image. Pick up any magazine, newspaper, annual report, or item of packaging for the proof. While illustration is in vogue and in the spotlight, however, there are designers who will gravitate to illustrative solutions. Design, in the role of the commissioner, holds the power.

Why is it that graphic design holds all the cards? The answer may lie in the role design plays in the production and realization of the final product. Illustration generally requires the graphic designer to package it for the

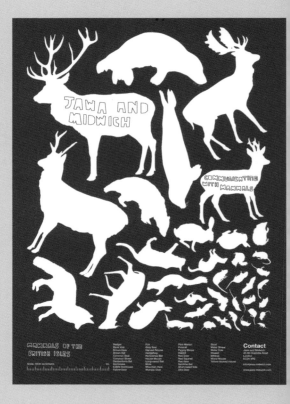

end user. Rarely will the illustrator deal with production, reprographics, and print, yet these aspects are part and parcel of the designer's responsibility. Illustration relies on graphic design to a certain extent.

Illustration is rarely commissioned by the end user. The illustrator will, primarily, produce work commissioned by a graphic designer or art director, sometimes without any direct communication with the client. Illustrators rarely initiate projects directly with clients, and if they do they tend to drop the label "illustrator" and rebrand themselves as designers. Illustration hasn't fought enough to hold onto its accolades; illustrators morph into designers when creative, production, and budgetary control is passed to them.

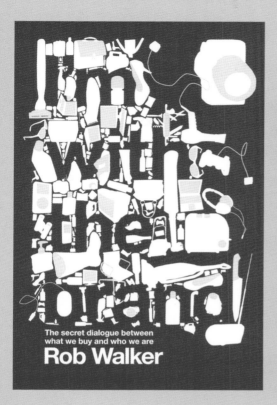

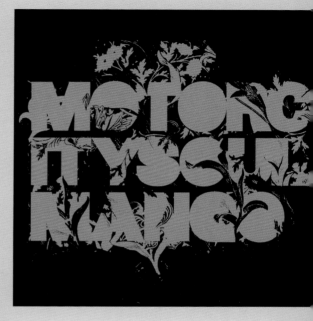

All images:
Book cover, record
sleeve, and posters
Digital
Jawa and Midwich have
created a body of work that
is characterized by their
inventive combination of
type and image. Whether
for commercial clients or for
self-initiated projects, the duo
walk the line between design
and illustration with impressive
results. For a jacket design
for *I'm With The Brand*, they
used the spaces between
hundreds of products to
create the letterforms for the
title. Floral illustrations and
patterns break up the bold
typography across their

record-sleeve design for
MotorCitySoul's *Mango*
on Freerange Records.
Better Than Nothing stands
as a company motto, and in
this self-promotional poster
Jawa and Midwich have used
thousands of small circles
to create larger letterforms.
In Mammals of the British
Isles, another self-promotional
poster, information graphics
meets conceptual illustration.
This poster depicts native
British mammals in order
of size, from the red deer to
the pigmy shrew. Fitting the
silhouettes neatly next to one
another indicates their relative
size, and a scale is provided
to show their actual size.

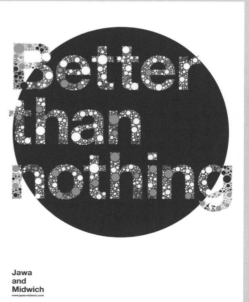

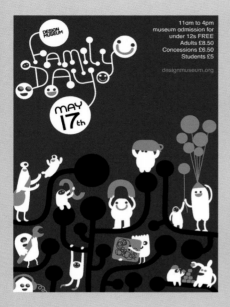

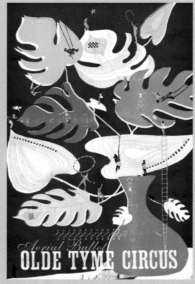

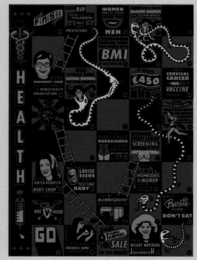

Top left:
Event poster
Digital, lithographic print
Richard Hogg's poster for a Family Day at the Design Museum in London uses characters, letterforms, and graphic devices to fuse text and image in a charming and fun way.

Top right:
Circus poster
Collage, digital
Increasingly, illustrators are turning to their graphic-arts roots. Natsko Seki, Japanese-born but UK-based illustrator, mixes digital collage and typography in this poster for a circus company.

Bottom left:
Press ad
Digital
In this press ad for fish4cars, Andy Smith, well known for his ability to merge letter-forms and illustration, makes a dramatic visual statement with his hand-rendered type dwarfing the car itself.

Bottom right:
Board game
Digital
Serge Seidlitz, based in London, but describing himself as an "English/German hybrid born in Kenya," designed this Health board game for UK television's Channel 4. Based on the well-known Snakes and Ladders, it fuses hand-rendered letterforms and illustrations to depict significant events related to women's health.

Recently, a more savvy, industry-aware illustrator has begun to emerge. This is due in part to the rise of digital technology, which has increased the options for creating a broader range of work across a wider range of applications, and also enabled illustrators to communicate on a global scale, showcasing their work to a more extensive range of clients. Many illustrators are now demanding a greater slice of the cake, as individuals, collectives, and studios.

Above left:
T-shirt
Digital
This T-shirt design by Adrian Johnson for 2K by Gingham plays on words and image to bring a smile to the viewer's lips. Referencing ecological issues and "tree hugging," the type and image communicate the same message, with the unspoken result suggested by the cactus spines.

Left:
Festival poster
Digital
Nordic Impulses, a music, theater, and visual arts festival in Norway, commissioned Grandpeople to create a promotional poster image. They chose to use elements drawn from classical operatic scenery, as opera is an artform that combines all the different aspects of the festival.

Illustration vs art

If illustration has an uneasy association with graphic design, it is tested even further in its relationship with art. The link between illustration and art was much closer in the past than it is today. During the Renaissance, art was largely figurative and commissioned to tell a story or promote an opinion, taking a role much like that of illustration today.

Contemporary art doesn't acknowledge the work of contemporary illustrators— rarely does it allow an illustrator to step into the fine-art world—but it does acknowledge the artist taking steps into illustration. Peter Blake, a preeminent pop artist, has worked as an illustrator and supports the discipline through his position as a patron of the Association of Illustrators (UK), but he is considered, first and foremost, an artist.

In 2000, Julian Opie's portraits of the four members of Britpop band Blur were part of a wider body of digitally created works all considered art rather than illustration because of the context for which they were created—the gallery rather than the mass market. However, in 2007 one of the portraits (of Alex James, the bass player) was used as the cover image for *Bit of a Blur*, his autobiography. Art became illustration.

Of course, like artists, many illustrators exhibit their personal work; they create one-off artworks and limited-edition prints not for commission, but as self-initiated projects. The importance of working on ventures and assignments outside the parameters of the formal brief is rarely underestimated by the professional illustrator: experimental works feed commercial projects both conceptually and stylistically. Creating self-initiated works plays a vital role in providing the illustrator with opportunities to take risks and explore subject matter and themes of a more personal nature.

Left:
Illustration/artwork
Pen, digital
Colin Henderson tackles surreal subject matter in his work, treading a thin line between fine art and illustration. This piece, created by hand using pen and ink, and on the computer in Adobe Illustrator, is titled Solace in Yo!ville. Henderson's alter ego Yo!Fest provides him with an outlet for his more art-based projects.

Above:
Portraits
Pen and ink, watercolor
Eleanor Meredith's ink, pen, and watercolor portraits are beautiful studies of real people, but are considered illustration and not art.

Newspaper supplement feature
Watercolor, ink, digital
For *The Sunday Telegraph*'s *Sunday Magazine*, Patrick Morgan drew this portrait of artist Damien Hirst—a case of illustrator meets artist.

Installation
Graphite, digital
Kenn Goodall's Fix Your Face was created as a large-format image for an installation at Designersblock, a London-based design event. Despite the raw emotions displayed within the artwork, and the personal nature of the subject, it remains an illustration rather than a piece of art.

Portrait
Digital
Today, Fernando Figowy's portrait falls into the category of illustration rather than art despite being self-initiated and noncommercial. However, before the birth of modern art, all portraiture was considered art.

Illustration vs photography

Illustration was the first medium reproduced to bring the written word to life. However, when photography arrived it did so with an impact that was all-consuming. From the moment the photographic image could be reproduced, illustration was effectively on the back foot.

Despite photography's impact, Picasso was less than impressed, regarding the medium as being in direct opposition to painting. "I have discovered photography," he proclaimed with more than just a hint of sarcasm. "Now I can kill myself. I have nothing else to learn." More recently, the iconic photographer David Bailey argued, "It takes a lot of imagination to be a good photographer. You need less imagination to be a good painter, because you can invent things. But in photography everything is so ordinary; it takes a lot of looking before you learn to see the extraordinary." Today the vast majority of images are photographic. As photographer and environmentalist Ansel Adams reasoned, "Not everybody trusts paintings, but people believe photographs."

The camera doesn't lie, or so it has always seemed. Even with the rapid rise of digital retouching, the public believe in the evidence supplied by the camera. Today the media is dominated by the photographic image and, consequently, photographers are held in higher esteem than illustrators. This is perhaps also due to the perceived complexities of traditional camera and darkroom techniques.

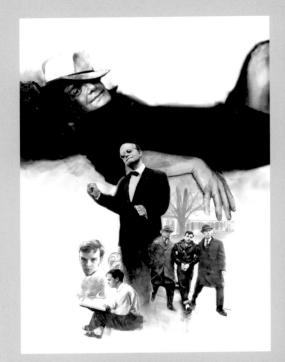

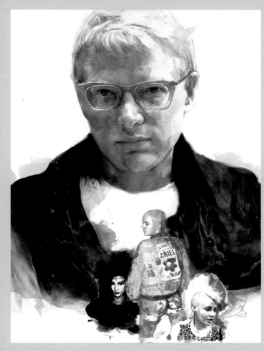

Top left:
Newspaper feature
Watercolor, digital
Berto Martínez, a Barcelona-based illustrator, creates portraits with a photographic basis. This illustration of Truman Capote, whom Martínez describes as "an alcoholic, a drug addict, and a genius," was created for *El Pais*, Spain's biggest national newspaper.

Left:
Poster
Digital
Susanne Paschke is a Berlin-based illustrator known for her highly detailed, almost photographic illustrations. She has produced work for a range of clients including Porsche, Mercedes-Benz, Siemens, and Nestlé. Paschke's illustrations are complex, each composed of up to 5,000 different forms, but despite tight deadlines she finds time to develop personal projects, such as this poster image, in her trademark hyperrealistic style.

Top center:
Magazine feature
Paint, photograph
For a feature in *GQ* Italy about Ted Polhemus, an anthropologist specializing in youth fashions and street styles, Martínez created this photograph-and-paint layered illustration. The camera plays a vital role in this illustrator's toolkit.

Top right:
T-shirt
Watercolor, digital
The Cameroon soccer team provided the inspiration for this image for a Uniqlo T-shirt commission. In typical Martínez style, it blurs the lines between the painted and the photographic image.

However, the advent of the digital camera changed photography forever. Today's illustrators use digital cameras and work on computers with similar ease. Despite an initially slow uptake of digital technology, contemporary illustrators consistently push hardware and software to their extremes. Combining the computer with digital photography was the logical next step.

For gathering reference material, the digital camera remains unsurpassed in terms of speed and portability, although the camera phone is fast catching up as technologies merge and memory capacity increases. With the digital camera in hand, many illustrators moved away from simply using photos as a reference from which to draw, to including photography within their illustration. Collage was an obvious route, but many went further still and the camera became as integral to image-making as the pencil or the paintbrush.

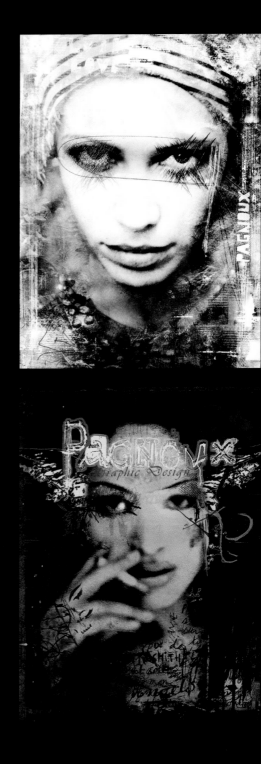

Far right:
Magazine feature
Paint, mixed media, collage, digital
Parisian illustrator Sandrine Pagnoux works with hand-rendered letterforms, drawings, textures, and photographic elements, to create moody, atmospheric images. This image accompanied an article about Aristotle and the cinema in *Le Magazine Littéraire*.

Right, top and bottom:
T-shirt
Photograph, paint, pencil
For Undiz T-shirts, Pagnoux produced photograph-based portraits, which she enhanced with paint and pencil.

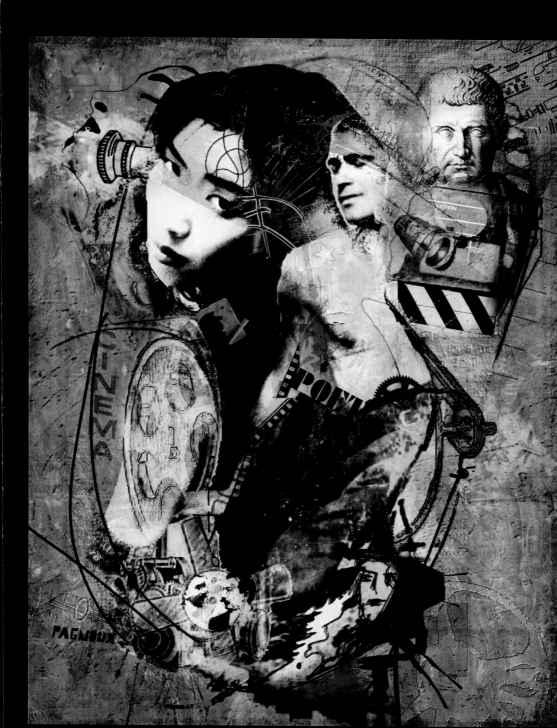

Illustrator as author

Illustration has been described as a commercial art, not able to function fully without a commissioning client. The truth is somewhat different. Most illustrators find a creative outlet in self-initiated projects, which provide a complement to commercial projects. While this is nothing new, in recent years a debate about the relative worth of the designer as author has raged within communication design, all but ignoring the relationship that illustrators have long had with self-authored projects. Illustrators have always recognized that to wait for a commission is to wait in vain, so most create their own work in order to prompt commissions from clients.

Top right:
Personal work
Pen
Chrissie Abbott's personal work explores phrases and sayings. This interpretation of "The end is nigh" was drawn to have a positive appearance somewhat at odds with the text.

Right:
Poster
Pen and ink
Tonwen Jones created this poster as part of a series of works that explore wordplay.

Far right:
Characters and icons
Digital
Simon Oxley, Japan-based British illustrator, divides his output between client-led commissions and self-initiated projects. Through the latter he has established his own brand, idokungfoo. Characters, icons, and symbols, often heavily inspired by Japan's pop culture, exist in the world Oxley has created for them.

idokungfoo for you

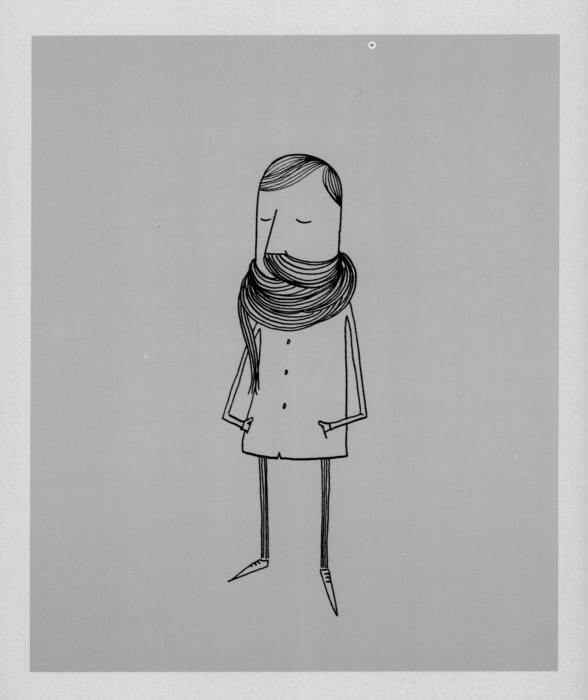

Self-published 'Zine
Digital
Circular is an illustration
from one of Robert Hanson's
self-published 'zines, sold
through various online and
real-world galleries and stores.
Freedom of expression and
the potential for new
commercial markets
encourage illustrators to
explore new opportunities
through self-publishing.

Cartoon
Pencil, paint
Paul Davis describes himself
as a visual journalist. Often
working without a set brief,
he explores diverse subject
matter and issues with his
own brand of dark humor and
angst-ridden drawing style.
While Davis maintains
a prolific output, much of
his work remains outside
the edges of conventional
illustration and it is through
self-published projects,
exhibitions, and joint ventures
with publishers and design
companies that his work
is made available.

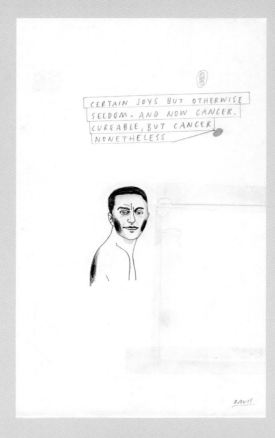

The significant detail for illustration is the change in how these self-initiated projects are viewed. In this the Internet has played a major role. Through it illustrators began to market self-authored projects to their peers. Having set up portfolio websites they added a few wares for sale, and from that they began to create small stores within their sites. This was a milestone for the discipline: for the first time illustrators could bypass designers and create work for their own audience. In doing so they created new markets: signed, limited-edition screen prints were mailed out to a growing number of buyers interested in contemporary illustration; web-based stores and portals displayed designs for T-shirts and encouraged audiences to vote for their favorite, printing the winning Ts in limited numbers for ever-receptive buyers. In Japan illustrators began a new trend by creating designer toys and vinyl figures, with artists in Hong Kong, New York, Sydney, and London following suit. The genre rose spectacularly and to date shows no signs of diminishing.

In moving self-initiated projects into new domains, illustrators found greater independence: they could develop, market, and sell their own product ranges. This gave illustrators a stronger voice, and the means to control their own destiny.

What next for illustration?

The 1990s saw illustration on its knees, but at the dawn of the twenty-first century it began to fight back with an excitement in the craft not seen since the 1960s and 1970s. Contemporary illustrators are seen as cool and visionary; they are courted by bands and brands from fashion and footwear to banking and cell phones. Illustration is a discipline with a currency in the here-and-now and a stake in the future.

Where next for a craft that relies on its relationship with advertising and graphic design for much of its revenue? Has the working practice of the new illustrators led to any fundamental changes in the craft's relationship with other disciplines? Have they established a greater equality?

The answer is both yes and no. Illustration remains a service industry, commissioned, used, and paid for by design companies, advertising agencies, publishing houses, record labels, and fashion brands, and as the commissioners, it is they who hold the power in the relationship.

The digital revolution, while arriving late to illustration, has presented new opportunities, not just in the creation, storage, and sending of images, but also in opening up international markets, and in creating new media for illustration to operate within. Illustrators can now choose to live in one country and work for clients in another; they are now commissioned to create images for media that previously didn't

Print and online campaign
Pen, digital
Cape Farewell commissions artists and designers to create works that raise awareness of climate change. Jody Barton created a series of images for one of its ongoing print and online campaigns. Barton often makes work concerned with environmental issues, and is driven by the important messages he wishes to communicate. Hard, edgy, and full of opinion, Barton's images are factual, powerful, and refuse to be ignored.

Print campaign
Digital

Spencer Wilson, a prolific and in-demand illustrator, still recognizes the importance of taking time out of a busy schedule to work on themes and ideas that interest and motivate him. Mocking up his idea, Be Good, Drive Small, into a print-campaign format develops his potential and helps future clients recognize how they might use his work. Wilson tackles this important and current issue with style and humor, and all completely in keeping with his portfolio of commercial work.

Poster
Digital

As illustration remains popular and the discipline continues to attract new practitioners, it is key that working methods and styles diversify and remain experimental. Adrian Fleet's poster for a Young Creatives Network (YCN) exhibition in Stockholm is a classic example of pushing boundaries. Fleet's drawings ignore styles and trends and therefore look fresh and challenging.

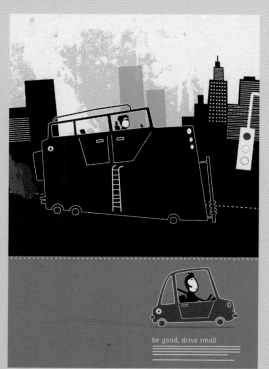

be good, drive small

exist, including content for cell-phone downloads, idents for web-based companies, images for downloads to accompany MP3 files, and work for the ever-expanding computer-games industry. And the list continues to grow.

Working for clients internationally isn't without its pressures. Understanding cultural differences is crucial, working across time zones without face-to-face contact can make it difficult to establish strong working relationships, and chasing payment from international clients can be stressful, but these are relatively small issues when weighed against the opportunity to expand your profile, establish a reputation, and build a broader client base. Those who work away from their home country can find inspiration in new locations—travel broadens the image-making as well as the mind.

Illustration is at a crossroads. It must continue to value its own worth, and be prepared to walk away if negotiations aren't favorable. How can the solo illustrator effect such a change? Illustrators are taking a lead from designers and setting up studios, collectives, and companies in greater numbers. They are dealing directly with those who commission illustration, and initiating bigger projects with the end-user, bringing designers, copywriters, and print companies on board as needed. With less reliance on agents and reps and more forward-thinking attitudes to winning work, illustrators can grasp hold of greater power, command more respect, and have a bigger slice of the cake. With more control comes greater influence.

Album cover
Mixed media, digital
For keyboardist Roger
O'Donnell's solo album
The Truth in Me, Ian Wright,
working with Martin Andersen
at Andersen M Studio, created
this deeply evocative cover.
Abstract shapes and patterns
reflect the atmospheric music
and sounds of the album
tracks, which were played
entirely on a Moog Voyager.
Wright has constantly pushed
the boundaries of illustration,
in a career spanning four
decades. He is a true
innovator, and maintains
an approach that leads
rather than follows.

Anatomy

Illustration isn't akin to other avenues of contemporary art and design. On the whole, the general public remain blissfully unaware of the role of the illustrator, unable to differentiate between illustration, graphic design, cartooning, animation, or aspects of fine-art practice.

Illustrators are viewed by many as part-time hobbyists, fine-tuning their craft at home alone, perhaps at a drawing board lit by an angle-poise lamp, with a radio play and a cat for company. Of course, unlike graphic design, illustration can't claim to touch every aspect of our lives. And unlike fine art it is rarely seen in galleries and museums, doesn't make headline news on changing hands for astronomical sums, or generate public debate when commissioned for public spaces. Illustration, on the face of it, has always remained the polite, reserved outsider, and this may well be due to the nature of the craft that eludes classification.

For most young artists, any initial formal training is in drawing and painting, learning basic skills that help them in their first attempts at expressing ideas visually. The first major choice for potential illustrators is whether to study art or design.

Along the road to becoming an illustrator, the journeyman isn't introduced to a specific tool of purpose, a medium that he or she must master before becoming a fully fledged craftsperson. Photographers may study camera techniques and ceramicists the qualities of clay, but illustrators have no one single tool or medium that best describes their relationship with the craft. Instead of mastering one defining medium, illustrators make a journey of discovery searching for the combination of tool or tools and working methods that will best express their style, and that will become their visual signature.

Just as illustration isn't about the use of any one particular medium—images can be created using any combination of drawing, painting, printmaking, collage, photography; can be flat artwork or 3D, analog or digital or both—the subject matter illustrators tackle is diverse. There are illustrators who see their remit as visual journalists, expressing their own take on the world around them; there are illustrators who translate politics or local, national, and international issues through their work; there are those interested solely in creating narrative images in response to given texts, or working on themes influenced by science or nature; there are those who work to inform and educate, others who wish to decorate and embellish. The decisions an illustrator makes in establishing their own working methods, developing their own style, and selecting the subject matter they investigate, are as varied as the markets they operate within.

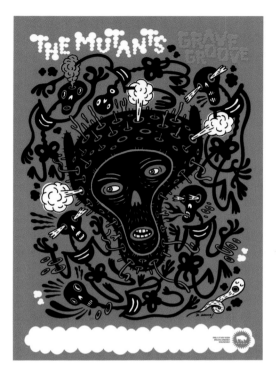

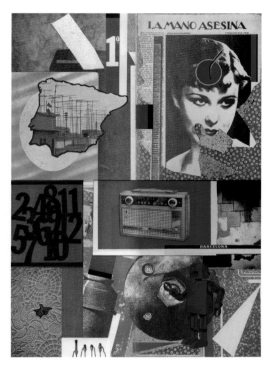

Poster campaign
Pen and ink, digital
Mexico-based Dr. Alderete
designed this poster as one
component of a campaign to
promote The Mutants' album
Grave Groove. Working with
ink on paper, then redrawing
and coloring digitally in
CorelDRAW, Alderete was
inspired by the iconography
of Mexico's Day of the Dead
celebrations.

Montage
Photograph, collage
On a visit to Barcelona,
Paul Burgess photographed
many objects and collected
numerous images and
mementos that captured
the city's essence. Drawing
influences from such study
trips is a key aspect of the
working methods Burgess
employs. Often working to his
own agenda rather than for a
commercial client, the images
he creates in response to
specific locations enrich his
experiences and his portfolio.

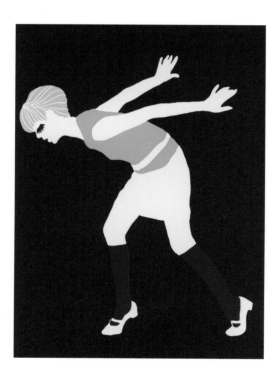

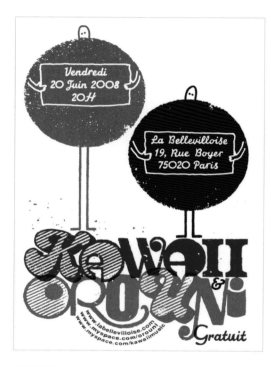

Personal work
Screen print
Marine's screen-printed image, Dance Girl, is a lesson in simplicity. She allows the color of the paper to show through in order to create the dancer's figure, and simple overprinting to create the girl's socks, T-shirt, and hair. The image is pure, decorative, and expressive.

Gig poster
Digital
This Andy Smith poster announced a Paris gig for bands Kawaii and Orouni. While being informative, it also expresses the character of the music and the event.

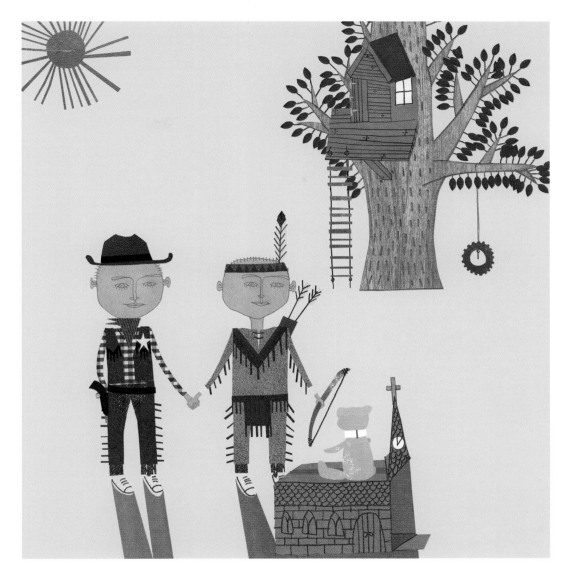

Newspaper feature
Mixed media
Graham Longdin created this
illustration for the *Guardian* to
accompany an article entitled
"Can a Four-Year-Old Boy
Know He's Gay?" Longdin
captured the innocence of
youth and friendships with
an image that offered his own
take on this potentially difficult
subject matter.

Drawing and painting

Drawing is at the heart of illustration. It provides the building blocks, if not the foundation stone, for all illustrative images. Drawing can be observational or interpretive, can reflect a mood or a moment, or be used to convey pure information.

Drawing pulls in every aspect of image-making. It is concerned with color and composition; shape, form, and texture; perspective and proportion. It is the language for research and visual note-taking; it is used in the creation of images for both pictorial realism and imaginative abstraction.

Illustrators, like other artists, must learn to see before they can learn to draw. Observational drawing forms the core from which every other type of mark-making develops. It is drawing that makes all ideas visual, from their beginnings in a sketchbook to their completion on a book cover, in a magazine, or on a CD sleeve.

The vast range of media and techniques that illustrators now employ only began to extend when the reproduction techniques of the past improved. It is now feasible to work in any media at one's disposal. The pencil, however, remains the most immediate tool. While it is basically a linear medium, the lines created can be made expressive through the pressure and speed of the drawing, and the grade of the pencil. Using a range of grades in a single drawing can make it easier to create a wider range of marks. Tone and texture can be produced by rubbing, shading, hatching, or using short strokes or a dot technique.

Both images:
Newspaper features
Ink on paper
Astrid Chesney creates powerful portraits. At first glance her characters appear charmingly innocent, but they reveal hidden depths, often displaying complex emotions. The story of two Italian men wrongly accused of murder and sent to the electric chair in the US during the 1920s, commissioned by *The New York Times*; and the life of a Chinese migrant in the UK working for an illegal gang, commissioned by the *Guardian*, are just two of the gritty stories Chesney has tackled in her work.

Pencils

Pencils are available in a range of grades. The European system generally runs from 10H (the hardest) to 10B (the softest). An "F" rating is also used, and this is widely considered to stand for "fine" or "firm." On the scale from 10H to 10B, F and HB come in the middle. In the US, a number-only system is also used. This runs from 1 to 4, with 1 having the softest, darkest lead and 4 the hardest, lightest lead. Comparing the two systems, B is equivalent to 1, HB to 2, F to 2.5, H to 3, and 2H to 4. The range offered differs from one manufacturer and one range to another. Koh-i-noor offers 20 grades from 10H to 8B for its 1500 series, Derwent produces 20 grades from 9H to 9B for its graphic pencils, and Staedtler produces 19 from 9H to 8B for its Mars Lumograph pencils.

The most commonly used pencils are graphite pencils. These have a smooth stroke, and leave a mark that ranges from light gray to black. Charcoal pencils give fuller blacks than graphite pencils, but tend to smudge easily. They are also available in a sepia tone, and white, which can be used for duotone illustrations. Carbon pencils produce a fuller black than graphite pencils, but are smoother than charcoal. Crayon or colored pencils have a wax core mixed with pigment. China markers, or grease pencils, have the advantage of writing on virtually any surface (including glass, plastic, metal, and photographs). Watercolor pencils, while intended for use with watercolor techniques, are also useful for achieving sharp, bold lines.

Magazine feature
Pen, pencil
Alison Casson used graphite and color pencils along with marker pens to create this illustration for a men's health magazine feature about the difference between the male and the female mind-set.

Pens

The pen also exists in many forms. Dip, or nib, pens and reed pens give a timeless feel through the quality of line they produce. In recent years it has become fashionable to use ballpoint pens for drawing, and their line has become a visual shorthand for doodling. Meanwhile, the quality of felt-tip pens has come to represent an old-school ethos and aesthetic, while that of permanent markers connotes the scrawl of urban graffiti or the immediacy of pop-inspired, color-saturated graphic art.

Pastels

Pastels provide the link between drawing and painting, or at least oil pastels do. Oil pastels are more difficult to blend than dry pastels, but are manufactured in over 500 colors. Oil pastels can be mixed and softened with turps and worked with a brush. They do not require a fixative, do not smudge, but are difficult to erase. Dry pastels are available in soft, hard, or pencil forms. Soft pastels give the brightest colors and are easy to blend, but also easy to smudge; to prevent this they require a fixative. Hard pastels give less brilliant colors, but are good for adding details, as are pastel pencils.

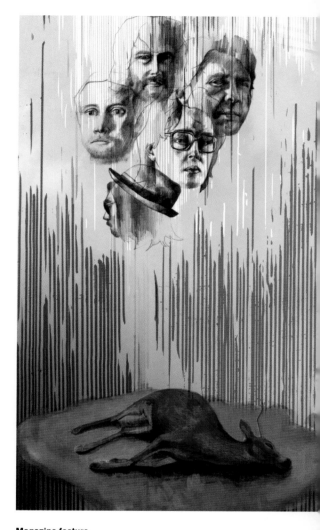

Magazine feature
Acrylic paint, graphite, digital
Bearded magazine is dedicated to covering independent music regardless of genre, background, or how fashionable it might be. Ken Goodall illustrated a feature about the Figurines, a Danish band, using acrylic paint and graphite pencil to create a dark image of the band and their music.

Paints

Painting, as an extension of drawing, offers a wealth of options for illustrators. From watercolors with their fluid color transitions, to gouache with its greater opacity; and from the fast-drying acrylics to the slower-drying, but often richer-colored oils, the range of media and related techniques is extensive. For over 400 years, oil paints have been the most widely used painting medium, though since the 1980s acrylics have become increasingly popular with illustrators due to their faster drying times. Digital drawing and painting tools have been around for only a relatively short time, of course, but they have made drying times irrelevant, at least for those illustrators who create their work entirely within software applications. It is no coincidence that the drawing and painting tools of software applications "recreate" the pencil, pen, and paint of the real world.

All images:
Personal work
Watercolor, gouache
During a trip to record the progress of Ghana's soccer team, The Black Stars, through the 2006 World Cup finals in Germany, illustrator and educator Tim Vyner drew as many illustrations of street soccer as he did of professional matches. At the European Championships in Portugal in 2004, he captured local fans gathered outside an old movie theater in Porto the day before the final. Vyner's reportage drawings, capturing his love of the game, have been displayed in galleries and also reproduced as limited-edition prints.

Photomontage, collage, and mixed media

Collage, derived from the French *coller*, meaning "to stick," is the name given to artworks made from an assemblage of different materials to create a new form. The term was coined by cubist artist Georges Braque in the early twentieth century. Usually stuck onto paper, card, or canvas, fragments or pieces of paper, photographs, fabrics, or other found materials are utilized, often with letterforms. The technique was first developed in China around 200 BC, following the invention of paper. The medium was in limited use until the tenth century, when calligraphers began to embellish their poems with glued paper. In Europe during the fifteenth and sixteenth centuries, gold leaf was applied to images in cathedrals, and gemstones and precious metals were applied to religious images.

Collage became a distinctive aspect of modern art as the cubists started to experiment with attaching fragments of newspaper and similar found images to their paintings. Early photomontage, the separate and distinct practice of creating a composite photograph by cutting and joining a number of other photographs, was first and most famously produced by Oscar Rejlander in 1857 in his *The Two Ways of Life*. Henry Peach Robinson followed in 1858 with *Fading Away*. The purpose of these works was to challenge the then-dominant painting and theatrical *tableaux vivants*.

Photomontage came to prominence in Berlin with the art of George Grosz and the rise of the Dada movement, around 1915. This was instrumental in making montage a recognized art form. The Dadaists, protesting the causes and interests that inspired WW1, coined the term "photomontage" around 1919. Alongside Grosz, John Heartfield and Hannah Höch created antiwar graphics with pioneering techniques that inspired the advertising industry from the late 1920s.

Collage and photomontage techniques first entered contemporary illustration with the optimism and hedonism of the 1960s. It provided a visual equivalent to the cut-up poetry and writings of Allen Ginsberg. Their popularity increased during the bleak realism of the 1970s, following a lead from the cut-and-paste of punk rock's graphic identity.

The late 1980s witnessed the arrival of digital color photocopiers and through that, illustration's love affair with collage surfaced once again. For the first time copiers could reproduce images in color, and reduce or enlarge individual components or an entire image, giving a far more unified and complete result.

Today, illustrators using collage or photomontage techniques are able to create their images entirely on the computer. In the early 1990s this was a popular use for Adobe Photoshop among graphic designers, but the most innovative and interesting work relies on the combination of the handcrafted and the digital. Whatever the methods employed, the techniques have remained true to their roots in revolutionary and counterculture art and design.

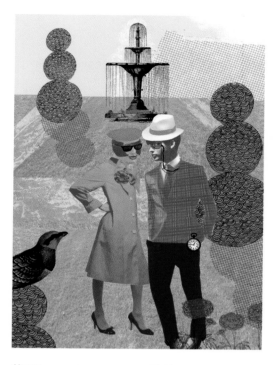

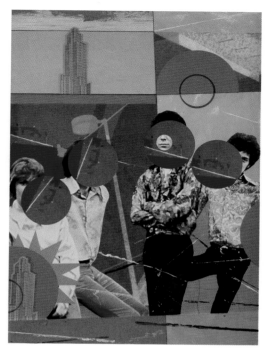

Above:
Magazine feature
Pen, pencil, collage
Tonwen Jones' collaged
couple, in a beautifully
manicured French garden,
represents the connection
between French women
and British men. The image,
entitled Cynicism and Chic,
was commissioned by *Elle*
magazine, Canada.

Above right:
Personal work
Mixed media, collage
In this collage, which uses
photographs, handpainted
textures, and rubber-stamped
images, Paul Burgess hides
as much as he reveals.

Right:
Personal sketchbook
Mixed media
Matt Wingfield, of MWS,
keeps sketchbooks of simple
collages that he creates with
found images and elements.
Wingfield works mainly in
retail graphics, designing
promotional campaigns for
fashion brands; he uses
his sketchbook collages to
help with his research and
development of commercial
client projects.

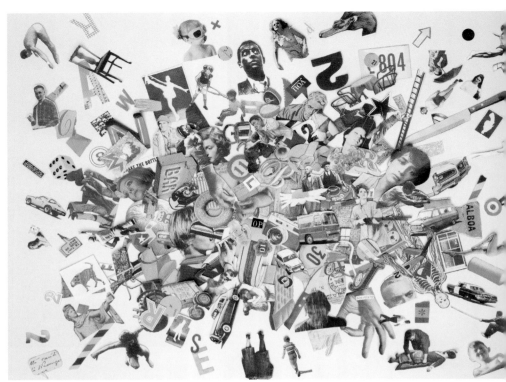

Magazine cover and book illustrations
Mixed media, collage
Martin O'Neill, working from his studio Cutitout, has a well-deserved reputation as one of the foremost talents in collaged illustration. Whether working on commercial projects, such as this cover illustration (above) for *Guardian* supplement *The Guide*, or on self-initiated projects such as his book *Dogs & Dice* (left, top and bottom), O'Neill creates artworks that retain something of each component part, yet communicate new meanings.

Analog working methods

The digital revolution had a dramatic effect on the ways in which we create and communicate, as well as the commercial outcomes and opportunities for contemporary illustration. Many of the most profound results—chiefly the positive labor- and time-saving aspects—on working practice have been woven seamlessly into everyday studio life by most contemporary illustrators.

The introduction of the computer has radically altered the many mundane tasks that are part and parcel of the illustrator's working day. The pre-digital illustrator might, for example, have started each morning by checking the post for payment for previous projects; today illustrators are most often paid by bank transfer, having e-mailed rather than posted invoices. The pre-digital illustrator may have had to plan his or her day around attending a face-to-face briefing for a new project; nowadays it is common to receive commissions from clients in different time zones via e-mail, perhaps with a phone call to consolidate opinions and thoughts. Roughs, or visuals, previously delivered in person, posted, or sent via fax, are e-mailed, which is far swifter and more convenient.

Not all changes, however, have been positive. An e-mailed visual often needs to be far more developed than the pencil-sketch visual of yesteryear. Illustrators are given less creative freedom early in projects as clients increasingly demand to see visuals more representative of the intended result. There is less regard generally for the final artwork stage and the magic that comes with producing a finished picture. And with the assumption that digital work can be altered at the flick of a switch, it is sometimes unclear when a project is fully completed.

In the days before computers, illustrators would schedule regular portfolio meetings with art directors and designers—those in a position to commission—in order to showcase their latest work. Often, as a preliminary to a meeting, illustrators would mail a postcard or other piece of printed material as a courtesy and visual tempter, and also to advertise and promote their work. Now portfolios are presented online, self-promotion is done via e-mails and blogs, and meetings between commissioners and commissionees are, sadly, becoming a rarity. Relationships are still being formed, of course, and in ever-more international circles, but with virtual-world rather than real-world collaborations the opportunities to discuss a project over coffee or a beer at the end of the day are ever-diminishing.

With an illustration project underway, researching a theme or checking a fact was not the quick hit to Google Images or Wikipedia that it now is; a previous generation thought nothing of scouring the shelves of libraries and bookstores for visual reference material, or mining the resources of thrift stores, and jumble and garage sales. This was seen as a perk of the job, or an occupational hazard, depending on the designer's point of view.

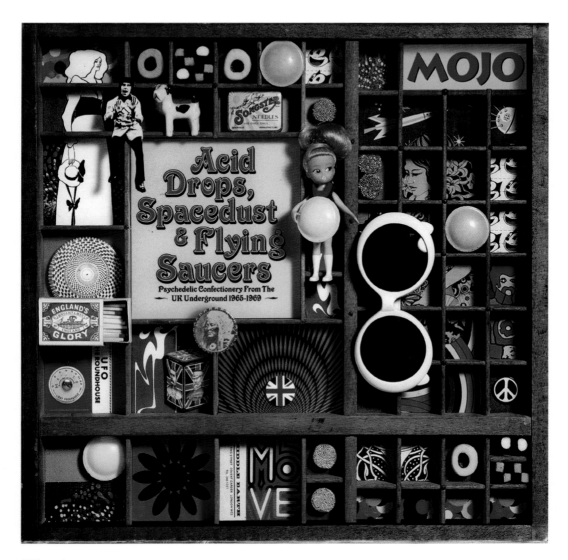

CD box set cover
Mixed media, collage
Paul Burgess placed found
objects and images into
each compartment of an old
letterpress type tray before
photographing the final result
to create this artwork for
MOJO magazine's *Acid Drops,
Spacedust & Flying Saucers*
box set of four CDs.

Prior to digital working methods, creating artwork for illustration involved many hand-craft techniques. Illustrators would create either camera-ready artwork that could be shot and dropped into place manually during the reproduction and printing stage of the process; or they created flexible artwork that could be wrapped around a drum-shaped scanner, which created color separations of the image in order to make a set of CMYK films used to produce the printing plates in off-set lithography.

Before the computer, drawing and painting were the most common methods by which illustrators created their artwork; photographic and collage techniques were also popular, and various forms of printmaking influenced illustration as well. Printmaking typified the craft of image-making prior to the digital age. Every aspect of printmaking emerged from the same basic principle—applying ink to a surface, be that a metal plate, block, or screen, and using that surface to print an image. While most printmaking techniques developed as a method of reproduction, artists and illustrators found that the outcomes had their own particular aesthetic qualities and began to use a range of print techniques, including relief printing, intaglio etching, lithography, and screen printing, to create one-off images.

With many so deeply immersed in the handcrafted nature of illustration, the rise of the computer and the shock of the new was all-consuming. The speed with which illustration's landscape was altered was too great for many practitioners—while the shock was not to last forever, the initial impact was immediate.

Left:
Magazine feature
Pen
For *Cookie*, a US parenting magazine, Roderick Mills captured a road trip through the state of Wyoming using just pen on paper.

Below left:
Catalog
Mixed media
Cornel Windlin commissioned Ian Wright to create Broken Chair, one of a set of low-fi images of chairs, for the catalog of furniture company Vitra. He used Hama Beads on a pegboard to represent a chair, showing only the most basic visual components, and ensuring that any flaws remained visible.

Below:
Magazine feature
Mixed media
Melvin Galapon created a set of portraits for *Wallpaper** magazine using tools for punching holes in card, giving his handcrafted images a low-fi appearance.

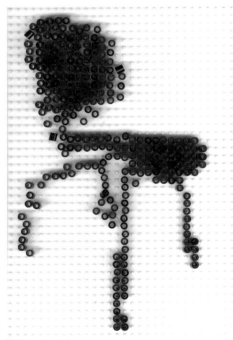

Digital working methods

It wasn't illustrators who first got to grips with digital technology, but graphic designers. Why did designers become immersed in making digital illustrations before illustrators could state their claim? The reason is twofold. Partly, this was down to simple economics. Designers had access to computers before illustrators because desktop-publishing software forced a complete reevaluation of their practice—design companies could not afford to miss the opportunity to invest in hardware and software and, more crucially, *could* afford the financial outlay required. Illustrators, mainly self-employed, were not in the same financial position to invest, and thus could not compete with the design companies as they embraced all things digital.

On top of that, the working process of designers is quite different from that of illustrators. The nature of their work requires designers to also be project managers; not only are they responsible for the design of a project, they often have to combine this with client liaison, briefing illustrators and photographers, art directing photo shoots, coordinating production, and checking print proofs. Proactive designers have always had to demonstrate an awareness of advances in technology, and the opportunities promised by digital media were too great to resist.

For the first time design could take place on-screen rather than on the drawing board, which allowed designers to "own" more of the process. Typesetters became redundant. The rules changed practically overnight. Pasteup artworkers were also left without work: pasting type and images to boards

in preparation for reproduction was a thing of the past—another job inherited, in a new form, by the graphic designer. For many designers it was a logical next step that illustration be created within the computer.

These first digital artworks didn't rely on strong drawing techniques, and often not on strong ideas. They showed more style than substance. Many designers, looking for inspiration, took their lead from the photomontages and collages of the past. Scanning, cutting, copying, and pasting were the tools of collage artists. The new ability to move, resize, and alter the color of images and elements on-screen allowed designers to create the first digital collages.

Below left:
Denim jacket
Digital
Dazed & Confused
commissioned Colin
Henderson to customize
a denim jacket. Inspired by
Native American patterns,
he cut the design into vinyl
by hand, then applied it
to the jacket's back panel.

Right and below:
Magazine features
Digital
Melvin Galapon fuses
old-school digital image-
making with simple graphic
concepts. *How To Make
A Better Website* (Redwood
Publishing) uses graphic
iconography to give a succinct
message; London Skyline
(*le cool* city guide) shows
Galapon's ability to produce
images that echo digital
media's early limitations.

When illustrators did begin to work with digital media, many simply followed the fashions in software usage, accepting that preset tools and filters would dictate their creative journey. An indulgence in vector drawing, seen as a backlash against the overused collage techniques, was a digital trend that both designers and illustrators embraced. Once again, drawing skills weren't required—images could be traced, and particular stylistic elements became commonplace. Characterless faces, butterflies, and rainbows featured heavily in much of the work. Ornamentation and decoration shone through as a reaction against flat vector graphics. Textile designs and, in particular, Victoriana, became influential. Patternmaking within digital illustration became a trend that many embraced. In recent years the work of renegade artists, and naive, childlike drawing styles, have influenced the look and feel of illustration.

Right:
Limited-edition print
Digital
This vector-drawn architectural impression of aspects of East Berlin, by Robert Hanson, was reproduced as a limited-edition screen print for Early Griffin Press.

Far right:
Book cover
Digital
This cover image for *Juego de Villanos* (Luisa Valenzuela, Thule Ediciones) relies solely on digital technology. It was created in Photoshop by Fernando Figowy.

While the mouse momentarily replaced the pencil and brush, a real interest in traditional craft skills within illustration has emerged, though there has not, and will not be, a full return to pre-digital image-making techniques. Images now are often made using both analog and digital working methods. Illustrators use the computer as a studio desktop—a place to bring together a range of methods to create an image that could only exist on-screen. Software designed to emulate real-world tools and traditional methods of mark-making, whether the vector-drawing tools in Adobe Illustrator, or the painterly options of Photoshop, doesn't offer a radical or valid alternative to the pencil, pen, and paintbrush. Intrinsically, the toolkit remains the same—even the various options, filters, and plug-ins serve only to enhance the basic software kit—but digital methods have enabled illustrators to take complete ownership of the creative process.

Constructing an image

The creation of an artwork is the culmination of a combination of creative thinking, ideas generation, and research. Rarely does an illustrator face a blank sheet of paper or an empty computer screen without any preconceived ideas about how they are going to create the final image.

During the process of brainstorming, illustrators generally create thumbnail sketches and initial visuals. These are often for client approval, before moving on to the artwork stage, but are just as often a route to finding the right visual direction for the job. Creating thumbnail sketches allows various options to be explored. Different ideas for composition and layout, color and medium, can be considered and resolved at this stage. However, there is an art to ensuring that the final rendition doesn't lose any of the spontaneity of the original sketch—a hazard of the need to work and rework ideas.

The prerequisites for the layout of a final artwork are likely to be set by the client's brief and the intended use of the image. Illustrators are most often given a format to work to—the dimensions of a book jacket will be fixed and a CD sleeve will have a definite format, while the size and shape of editorial illustrations may be dictated by the layout of the page they will appear on. Once the overall format of the image has

been decided, an illustrator can start working on a composition to best express the idea. Most illustrators work according to intuition. They have the freedom to construct real or imaginary scenarios in order to express an idea. The best contemporary illustrators capture the imagination of the viewer with engaging ideas expressed through an image that draws in their eye and leads them through the picture in a systematic way. A figure in the foreground, the use of bold shapes and patterns, or the dramatic use of light and shade are just some of the methods that illustrators can use to create tension in a picture.

Below left:
Magazine feature
Pen, digital
Japanese illustrator Asako Masunouchi created this illustration about ecosystem cities for the SNCF's (French National Railway Company) *TGV Magazine*. The landscape composition, with trees and deer at either side, draws the eye in; the wheel of the bicycle becomes a central axis for other elements within the picture; and the lake in the mid-ground leads the eye to the horizon line and the mountain range beyond.

Below:
T-shirt
Digital
Jesse Chapolito, San Diego–based illustrator, created this T-shirt design around the theme of clubs and parties. The image, designed to fit the format of the shirt, is based loosely on a symmetrical design.

Visualizing ideas

The essence of the illustrator's job is adding meaning and life to a specific text or message. The core of a successful illustration is the thinking behind it. It is ideas and concepts that form the basis of an image that communicates intelligently. The means by which illustrators arrive at a visual solution most often involves the combination of analytical and creative thinking with refined practical skills.

There are no hard-and-fast rules regarding successful ideas generation, though the starting point for many illustrators is a pencil and sketchbook. The most appropriate course of action for an illustrator facing a new commission is to begin at the beginning—with the brief. Only by truly understanding what is being requested can the illustrator begin to explore a visual response. Project briefs can vary from hastily composed e-mails and short telephone conversations through to fully specified documents, complete with job dimensions, dates for delivery of visuals and final artwork, a breakdown of the fee and payment terms, and full usage and rights information.

Newspaper and magazine editorial illustrators may work to an edited text article, or a simple conversation with the writer or journalist about the overall approach and point of view of the piece. In book publishing some art departments provide the illustrator with an entire manuscript to read before asking them to embark upon a cover design, while others provide just a basic synopsis of the storyline or subject matter. Advertising art directors often have a very specific idea or concept in mind and want to buy an illustrative style rather than a creative thought process. A record company art director might be looking for an illustrator's artistic interpretation of a band's musical output.

With such variation in the nature of briefs, experience pays real dividends, but whatever your level of experience, ensuring that every aspect of the project brief is fully understood will help you choose the right approach to ideas generation. Undertake some research and investigation into the subject matter. Illustrators often acknowledge that this aspect of their working process requires the rapid gathering of expertise and knowledge. Researching a subject can mean a quick hit on relevant websites; a trip to a library or bookstore for in-depth reading matter; or a visit to a museum, gallery, or particular place of interest.

Once the brief and the subject matter are understood, illustrators can embark on the generation of ideas. Most employ a range of methodologies for creative and conceptual thinking—the process of brainstorming. One way to start is by writing down associated words, however tenuous the link, in list form. Another way to begin is by drawing thumbnail sketches of scenes, objects, and people that have some connection with the problem to be solved. These may lead to more concrete, fully formed ideas. The only rule is to get as many thoughts down, written or drawn, as soon as possible. Projects with longer schedules might allow some pondering over the course of an afternoon, or even a couple of days. Time to consider a brief can certainly help alleviate the pressure of having to be creative at the flick of a switch.

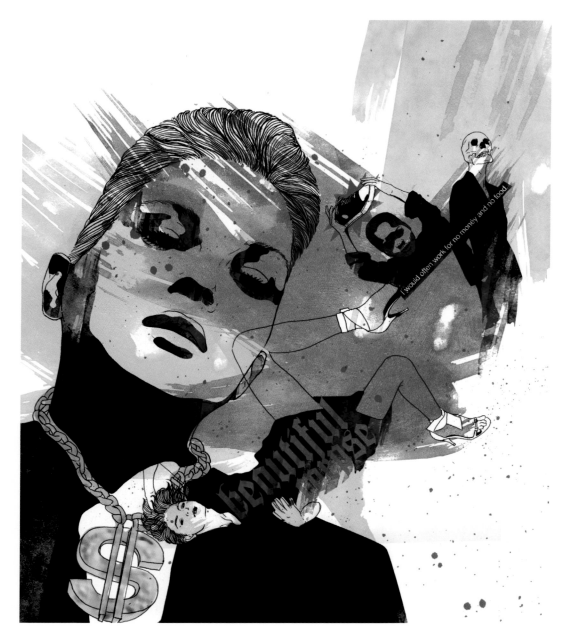

Magazine feature
Pen, digital
Illustrators can and do use their work to express
ideas that they feel strongly about. Oscar Gimenez
took a critical view of aspects of the fashion industry,
and in particular the use of size zero models, in this
image for the 100th issue of *Art & Design* magazine.

Right:
Personal work
Acrylic paint
Creating an image is about
making a visual statement that
gives a sense of place and
ambience. Emerald Lagoon,
by Chris Long, is less about
conveying an idea and more
about capturing a moment.
It was inspired by the exotic-
looking record covers of
the 1950s and 1960s.

Far right:
Newspaper review
For a newspaper review of
Monster Love (Carol Topolski),
Brett Ryder created this
disturbing image. The story
of the love between two
psychopaths and the murder
of their daughter is a grotesque
tale. While Ryder's image
expresses the subject in
a chilling manner, it allows
the viewer the opportunity to
contemplate the theme of the
book through a clever visual
idea expertly executed.

Left:
Brochure
Digital
Spencer Wilson's simple
idea, a musician struggling
under the weight of her
instrument, is a beautifully
crafted example of pared-
down visual information.
The shadow both emphasizes
the struggle and situates the
figure on the page, without
a single detail surplus to
requirements.

Many illustrators choose to archive printed ephemera and collected materials that they can later turn to for inspiration at the ideas stage of a project. Such archives can provide a useful resource for drawing references, and for ideas on color combinations, for example. Mood boards can be created as an extension of the archive. More often employed by graphic designers, fashion designers, and architects, mood boards can be useful for some illustration projects.

For those who prefer to start with a clean sheet of paper, a pencil or pen, and their own thoughts, there are other routes. In addition to making lists and/or sketches, spider diagrams can be created to kick-start conceptual thinking. These involve highlighting links between ideas by joining elements and

ideas with drawn lines. More conceptual- and lateral-thinking exercises might involve tackling the project from a range of different viewpoints. For the professional illustrator, the most effective mechanism for creative thinking rests purely in the recognition of the particular technique, or range of techniques, that work for them. This is likely to have evolved over time. Illustrators have to hone their skills.

Maintaining confidence in your ability to resolve a complex problem with a succinct and creative visual solution can be the hardest barrier to overcome. Keeping positive and letting your creative juices flow freely while under pressure from an impending deadline comes with practice and experience.

Color

Color is a very subjective topic. Any one color may have many associations. While it is understood that color has a role to play in a visual message, color is also one of the most overlooked aspects of a project for the contemporary illustrator. It is because color can communicate so well that the artist must be aware of the choices being made, and of how an audience might respond to certain colors. Being aware of associations, both nationally and internationally, can help an illustrator convey a visual message on psychological and emotional levels.

We experience color through one sense only—sight—but viewing something begins the process of reacting to it; once we see a color, our mind processes its stored associations to give meaning to that color.

Color associations differ from person to person, and from culture to culture. People respond to color in different ways, most often on a subconscious, emotional level. Illustrators working for global audiences can never make simple assumptions. In the West, for example, black is associated with death, while in the East, white is the

traditional color of mourning. In Islam, green is associated with Paradise; in Ireland it is associated with luck. In Native American cultures blue represents north, cold, defeat, and trouble; white represents south, warmth, peace, and happiness.

An illustration can be enhanced by the use of strong color. On a functional level color contributes to visibility, contrast, and legibility, but it is the emotive use of color that attracts most illustrators to working with particular palettes. Illustrators who can use color well can achieve dramatic results.

Below left:
Book illustration
Pen, pencil
For Unmadeup Publishing's *The Illustrated Brighton Moment*, Oliver Hydes illustrated a busy street scene in the city's center. Showing the shop signage in black-and-white, Hydes uses color to emphasize the chaotic nature and random movement of the crowds.

Below, far left:
Event promotion
Gouache, watercolor, poster paint
Mimi Leung, Hong Kong–born but UK-based illustrator, created this artwork for events organizer Far East Far

Out to promote a disco-punk party night entitled You Say Party/We Say Die! Hand-painted with watercolor, gouache, and poster color paints on paper, this vibrant picture explodes with color.

Below:
Personal work
Digital
In this self-initiated image about US chess prodigy Bobby Fischer, German-born, Finnish-based illustrator Daniel Stolle uses only the crucial elements to depict his idea. By stripping back the color, he represents something of Fischer's anti-American stance.

Visual metaphors

The visual metaphor is a common tool in the illustrator's toolkit. A visual metaphor involves the use of an image that represents or suggests one type of object or idea in place of another, more obvious image, to suggest a likeness or analogy between them. Used effectively, it can bring an extra level of meaning to an illustration, and convey concepts and ideas in intelligent and thought-provoking ways. Visual metaphors require a certain level of imagination and lateral thinking—they cannot be read, or viewed, literally. We know that money doesn't grow on trees, but an illustration of banknotes sprouting from branches can communicate this message because it has an accepted interpretation. Conceptual in nature, visual metaphors present their audience with more complex and ambiguous meanings than literal images. Visual metaphors evolved within illustration, possibly influenced by surrealism, as a means of expressing ideas and concepts rather than portraying realistic scenes.

Below left:
Magazine and newspaper features
Collage, digital
Brett Ryder creates seemingly real worlds inhabited by seemingly real people, but located in surreal moments. Ryder gives dry subject matter a conceptual twist. He created this image for *New Scientist* magazine.

Below:
Public information poster
Pen, pencil, digital
Oliver Hydes used hand-rendered letterforms in this image to reinforce his message about the link between sunbathing and skin cancer.

Short story illustrations
Gouache, watercolor, poster paints
Mimi Leung drew this intriguing image as one of a set of illustrations for a selection of short stories by Haruki Murakami, *Blind Willow, Sleeping Woman*. The swirling mass on the back of this character represents the weight of predicament.

Signs, symbols, and icons

The use of signs, symbols, and icons in illustration has become increasingly popular. Signs and symbols were man's first attempt at graphic design. The need for nonverbal communication isn't new; cave painters, Egyptian scribes, religious painters, and other artists have developed their own systems for communicating visually. The simple graphic of an arrow carved into a tree as a means of wayfinding, for example, is evidence of the historical understanding we have for symbols and their meanings.

T-shirt
Pen, collage, digital
Chrissie Abbott designed this image for Nylon x Urban Outfitters. A combination of sign and symbol, it is a graphic update of the Tree of Life.

Signs and symbols are visual artifacts that offer information and communicate a message quickly. Today there is an unceasing demand for instantaneous and international communication. With the lack of a common language a potential barrier to communication, the need to devise graphic alternatives is obvious.

Illustration has evolved to encompass graphic elements such as signs and icons, along with other aspects of visual communication usually associated with diagrams and information graphics. These graphic devices have a resonance that, while communicating themes in a succinct fashion, can also give illustrations a cool, impersonal, and manufactured feel.

Subverting signs and symbols has become a rich resource for illustrators keen to give new meaning to, and suggest new interpretations of, well-known icons. Modern symbols and signs give us advice, directions, and warnings, and appear almost everywhere. It is little wonder that illustrators now plunder this supply for inclusion in their work. Illustration draws upon contemporary society at every level, and the signs and icons of the twenty-first century are no exception.

T-shirt
Digital
Andrew Groves of
IMAKETHINGS created this
T-shirt design for Japanese
company graniph. His image
is composed of a simple set
of icons representing things
that he saw on a day trip from
Tokyo to Kanagawa.

Narratives and storytelling

Illustrated children's books, graphic novels, and comic strips all rely on the sequential image. Such projects might call for the elucidation of a text, or a more enigmatic rendering of the subject or storyline—the role of the illustrator will depend on the nature of the assignment. Working within narrative illustration requires an under-standing of order and structure: images must be planned as a set of sequences, and this demands the consideration of effects such as timing, pace, rhythm and flow, pause and rest. The illustrator should also consider introducing an element of surprise and suspense, perhaps through the effects of repetition and consistency, change and contrast, gesture and expression, reflection and flashback.

Animation and stickers
Pen, pencil, digital
For Does it Offend You, Yeah?, a band signed to Virgin Records, Mark Taplin created an animation sequence to accompany the single "Let's Make Out." Mixing up inspirations and references that included the cult 1970s TV cartoon *Wacky Races* with characters influenced by the films of Russ Meyer, Taplin produced a narrative based around a dragster race. To accompany the animation a promotional sticker set was produced.

There are no hard-and-fast rules to follow when sequencing images, but planning and producing a storyboard is an essential second step. The first is to read and comprehend the text. Give careful consideration to which are the most appropriate aspects of the storyline to illustrate. Ask yourself how and where the story starts? Identify when it is set, and who the main characters are? What is the main plotline and how do any subplots relate to it? Which aspects of the text have the potential to be most visually interesting?

The storyboard, a set of thumbnail sketches placed in running order, will provide you with a very useful overview of the entire sequence, allowing for early planning of the relationship that each image has to the narrative, the effect of the running order, and the composition or viewpoint within each image. It will also help you to focus on, and refine, such factors as locations, character development, precise composition, light sources, and the use of props.

Before you start on the final artworks, visuals are a critical next stage. The budget, along with technical requirements and constraints, will determine how much time and detail you can put into these.

Audience interest must be maintained throughout a storyline. Changes in format, viewpoint, and scale, for example, can help to keep a set of images interesting, but a sense of continuity is crucial: some repetition of pictorial elements within a sequence can help to ground a story. The number of illustrations required, together with the design of the project, will affect the size of individual images.

The logical next step for illustrators working with static sequential images is to move into animation. There is an allure in seeing one's own static drawings brought to life through simple animation, whether through digital or analog methods. Equally strong is the lure of the advertising-agency budget and production facilities. Such commissions can allow illustrators to adopt a fashionable stylistic approach.

The sophisticated planning and application that working with sequential images requires makes this a complex, but rewarding discipline.

Comic strip
Pen, pencil, digital
Mark Taplin designed this powerful comic strip for ActionAid to illustrate the issues surrounding world hunger. He represents hunger as a man-made monster wreaking devastation and panic.

Aiming for originality

The question of originality in art and design is a fascinating one. Some believe there is very little that is truly original, that rarely can an image or design stand completely on its own, without influence and without peers. The best most professional illustrators can aim for is to create work that explores the scope of their own visual signature.

Originality can shine through when an image-maker has an intuitive visual language. It isn't realistic to believe that all newcomers can bring something unique to the discipline, but while it is understood that innovators create new styles that others will follow, there is little respect for those who simply imitate their work.

Certainly, maintaining a career as an illustrator isn't easy, and the temptation for inexperienced artists to emulate rather than innovate can be great. By ensuring that influences come into illustration from other disciplines—art, architecture, theater, movies, and literature, for example—the subject can continue to move forward. Ultimately, simply following the stylistic lead of other illustrators can only reduce the quality of work generally, and damage the perception of illustration as a relevant contemporary practice with a resonance in art and design.

Left:
Magazine feature
Acrylic paint
While Ian Wright's portrait of
hip-hop producer J. Dilla for
Straight No Chaser shows
just one stage in the constant
evolution of his working
methods, the economy of line
ensures that this portrait could
have only one signature—
that of Mr Ian Wright.

Far left:
Magazine feature
Pen, pencil, ink, gouache,
collage
Nick White combined
collage, felt-tip pens,
pencils, crayons, ink, and
gouache paint to make this
rather surreal picture. It was
commissioned by *Plan B*
magazine to accompany an
article about bands that use
voice as the basis for their
music. His abstract direction
results in an original take
on the subject matter.

Newspapers

Editorial is often regarded as the starting point for a career in illustration. Newspapers, perhaps the most visible arena in which illustrators can "cut their teeth," have the associated "wow" factor of a commission being turned around—from conception to creation, into print, and onto the news-stands—within 24 hours. And they are relatively forgiving, given their short life span. But such a simplistic view would greatly undervalue the skills needed to work successfully for the press industry.

Today's newspapers require illustrators who can create images that provide a visual commentary on the journalist's copy. The overarching goal of newspaper illustrations is to work alongside the story or report. On any given day, a plethora of news items, current affairs, issues, topics, and commentaries run through the pages of newspapers around the globe—illustration's role is to provide these stories with an individual stance or viewpoint, and to contrast with the photographic images that dominate newspapers today.

Newspaper illustration has a long history: America's oldest paper, *The Boston Newsletter*, was first published in 1704; and *The Times* was launched in the UK in 1785. However, it was when *The Illustrated London News* arrived that newspaper illustration truly came of age.

First appearing in May 1842, it had around two illustrations per page. As a 16-page publication, this gave a total of 32—all woodcuts. These images depicted global news stories that included features on the war in Afghanistan, a rail crash in France, and a party at Buckingham Palace, all seemingly timeless events that could so easily feature in a newspaper today.

Nearly 170 years later, illustration is rarely used as the primary visual reference, but where photography is seen as more factual, illustration offers opinion and a point of view to back up the stance that the newspaper or journalist takes. The very best of contemporary newspaper illustration is ambitious, thought-provoking, and sometimes controversial. Illustration has the power to communicate graphic messages that encourage debate and forge differing views rather than merely "decorating" the journalist's text.

Right and overleaf:
Current affairs features
Pen, pencil, digital
Jason Ford works regularly for numerous national and international newspapers. His ability to resolve often complex problems with visual solutions that distill an idea through a simple graphic is essential for this task. His images communicate succinctly and successfully. These illustrations were for an article in *The Independent* (right) about the continually changing digital world, and in the *Guardian* (overleaf) about the ruthless behavior of water companies.

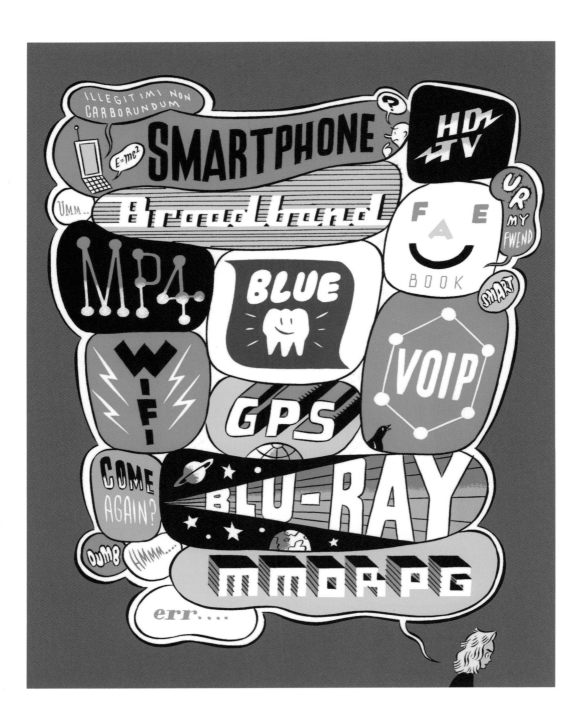

This page:
Political columns
Digital
Lawrence Zeegen illustrates
a regular column, "Comment
& Debate," for the *Guardian*.
The news articles are current,
the debates often politically
charged, and the deadline just
two or three hours after the
commission arrives. The ability
to think fast, visualize an idea
for approval, and create final
artwork within a few hours
is a given.

General-interest features
Acrylic paint, pencil, digital
In contrast to Zeegen and
Ford, Toby Morrison allows
the hand-drawn lines and
brush strokes of his work
to remain evident. These
images, again for the
Guardian, demonstrate
strong analytical and creative
thinking perfectly combined
with a unique illustrative style.
Morrison tackles the financial
downturn, lottery winners who
retain their menial jobs, and
the Labour government's
electioneering.

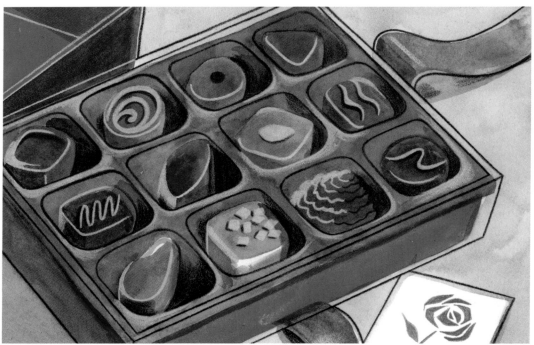

Magazines

Magazines live a little longer than newspapers. If today's newspapers are tomorrow's trash, magazines will hit the recycling bin after a month, or live on death row in a surgery waiting room. While a newspaper illustration has just one opportunity to make a point—in that moment before the reader turns the page and leaves it behind forever—an illustration in a magazine gets a little longer, but has to arouse the interest of both the casual browser and the avid reader.

There are many more magazines being produced today than ever before, covering an ever-increasing range of subject matter. Many are instantly recognizable "titles" that can be purchased internationally at newsstands and newsdealers; others are in-house publications for a variety of commercial companies and businesses. Every bank, airline, insurance company, and large retailer offers its customers a consumer magazine, and specialist trade magazines cover every conceivable interest.

Those working in editorial illustration recognize that budgets remain tight, and that to work solely within this sphere of the industry requires an ever-flowing stream of commissions, yet many illustrators regard magazine projects as the bread-and-butter of their careers. Often the flip side to a tight deadline and a tighter budget is the creative freedom that editorial illustration allows—editorial commissions provide an opportunity for illustrators to showcase innovations in their working practices.

Navel-gazing, however, does not provide the foundation of a successful career path. Illustrators working in this field must become instant experts on the subject matter of their commission. A magazine commission might demand the visual interpretation of complex scientific theories, philosophical ideas, political ideologies, or international financial markets. At the other end of the scale, and a far more decorative use of illustration, it might require insight into celebrity relationships, star signs and horoscopes, recipes, or illustrated maps.

Magazine covers
Digital
The Illustrated Ape produced two covers for its "North vs South" issue, using JAKe's illustrations to excellent effect. The different, yet very similar explorers, both in disguise, create an intriguing image.

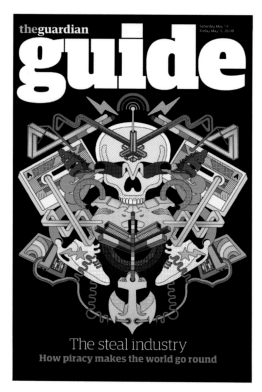

The scope for editorial illustration knows no boundaries. Although magazines can arrive on the scene to disappear without trace just months later, the constant appetite of consumers ensures that new magazines launch continuously, creating a steady income stream for those, with the relevant skills and expertise, who choose to specialize in this field.

Neither transitory nor permanent, magazine illustrations have a role, a purpose, and a fan base. Time and money may be in short supply, but an opportunity for the jobbing illustrator to test their creative mind and working methods is one too tempting to resist.

**Left, above and below:
Magazine and newspaper
supplement covers
Digital**
Jamie Cullen's distinctive
images create eye-catching
covers. His brief from the
Guardian: The Guide required
an image depicting piracy
and copyright issues in youth
culture, while that for *Design
Week* stipulated that a light-
bulb be included in the image.

**Above and right:
Magazine features
Pencil, digital**
Paul Davis takes a wry look
at Brick Lane in London's
East End for US design
magazine *Print*, while Oliver
Hydes represents an Iranian
rapper's lyrics of protest for
Susology magazine.

Magazine covers
Mixed media
Nigel Robinson, an illustrator
with a background in graphic
design, created these cover
illustrations for *Wallpaper**,
an international design,
interiors, and lifestyle
magazine. Robinson's
images are beautifully
executed, stylish solutions.

er*

UK £3.90
US $8.75
AUSTRIA € 9.00
AUSTRALIA $ 8.95
BELGIUM € 7.70
CANADA $ 10.95
DENMARK DKR 73.75
FRANCE € 7.70
GERMANY € 9.50
HOLLAND € 7.70
ITALY € 8.50
SPAIN € 7.70
SWEDEN SEK 69.00
SWITZERLAND CHF 15.70

ERNATIONAL DESIGN INTERIORS LIFESTYLE

mbers' bars & Maître d's

Bespoke (Americas)

Wallpaper*

JANUARY | FEBRUARY 2005 *INTERNATIONAL DESIGN INTERIORS LIFESTYLE

UK £3.90
US $8.75
AUSTRIA €9.00
AUSTRALIA $12.25
BELGIUM €7.70
CANADA $10.95
DENMARK DKR 73.75
FRANCE €7.70
GERMANY €9.50
HOLLAND €7.70
ITALY €8.50
SPAIN €7.70
SWEDEN SEK 69.00
SWITZERLAND CHF 15.70

The Design Awards

Inaugural issue

9 771364 447046 01

AOL Keyword: Wallpaper Magazine

Book covers

You should never judge a book by its cover, but it is obvious that many consumers do. Books are often purchased in the rush to catch a plane, at a three-for-two promotional stand in a bookstore, or from an image and brief description online.

While book reviews are widely available, the bottom line for so many of the book-buying public is one of three factors: the opening lines of the book, a few select quotes from well-chosen reviews, or the impression the cover gives. And the cover is not in the remit of the author—it is a design issue.

A book cover has a very particular set of functions to perform: it must give the title of the book and the author's name; it must also indicate the publisher and the price of the book, along with its barcode and ISBN number. After that, anything goes—within reason, of course. Design's role is to bring the content of the book to life, to convey its subject matter and tone in a visual form, and to create a character with which readers will identify. And as the first point of contact for potential buyers, the primary role for any cover is to sell the book. It must stand out from its competitors, it must understand its audience and their tastes. A book jacket must work as packaging, a marketing device, a mini poster in shops, and as a visual identity for the book. It must:

- draw attention to the book;
- be visually iconic;
- be relevant to the subject; and
- perform these tasks in a distinctive style.

Word and image work together on a book cover and, while rarely under the control of the illustrator, the best design solutions come about when text and image are considered together, as complementary elements within an integrated design. Of course, completely integrated text-and-image solutions can come about when illustrators hand-render letterforms as part of an overall design concept.

Working as an illustrator within this field often throws up a particular challenge. The creation of a book cover is usually a process of "design by committee," with the needs and opinions of sales and marketing departments, art directors, publishers, and authors to be considered, and the inevitable compromise that entails. Maintaining enthusiasm and keeping a level head with so many views to juggle can be an art in itself.

Book covers
Digital

Monika Aichele's cover illustration for *Helicopter Man* (Elizabeth Fensham, Bloomsbury), about a tricky father–son relationship; and Roderick Mills' cover for *Talk of the Town* (Jacob Polley, Macmillan), about a schoolboy growing up in Carlisle, in the north of England, both make use of hand-rendered letter-forms so that the book titles are in keeping with the cover illustrations, ensuring that the overall look and feel of each book is fully integrated.

Book covers
Digital
For both *Bonne à Tout Faire* (Saira Rao, Editions Générales) and *Arrête de Flaner, Cupidon!* (Lorelei Mathias, Editions Générales), Delicatessen used a character central to the book's plot for the cover design.

Book covers
Digital
Andy Smith, known for
his hand-rendered fonts,
cleverly integrates type and
image for *The Reverend
Guppy's Aquarium* (Philip
Dodd, Random House),
and *The Brain-Dead
Megaphone* (George
Saunders, Bloomsbury).

Children's books

Most people are introduced to illustration through children's books. Years after reading them people still recall the stories, characters, and scenes illustrated in their favorite books. For many people they hold a special place in memories of childhood.

The history of illustration is intertwined with the history of the book. For 400 years, until the invention of photography, illustration was the only form that printed images could take. The first widespread examples of children's books, featuring storytelling rather than educational instruction, appeared in the nineteenth century when the invention of color lithography allowed the genre to expand.

The beginning of the twentieth century saw a rapid rise in the number of titles available for children, with a growing number of illustrators, among them Edward Ardizzone and E. H. Shepard, becoming known solely for their work in this field. The children's book industry continued to grow throughout the century and today many illustrators, including Quentin Blake and Michael Foreman, are as well known to their audience as the authors of the books their work illustrates.

Left:
Picture book
Pen, digital
El Monstruo de Colores no Tiene Boca is a compilation of stories written by children from Mexico, Spain, and Brazil, recounting their dreams. This image, by Mexican illustrator Dr. Alderete, depicts a dream about monsters putting a child into a paella, watched by the octopus parents of the little girl.

Top right:
Notebook
Digital
Brazil-based illustration and design studio Mopa designed this cover for a notebook for Argentina-based Monoblock. The theme—Live the Love, Happy Together—is beautifully expressed through images, pattern, color, and text.

Right:
Educational book
Acrylic paint
Chris Long illustrated a series of books encouraging parents to participate more fully in their children's development. Long's illustrative style brings positivity to the publication—the fluid, pop-style images are upbeat and brightly colored.

A glance around the children's section of any major bookstore will reveal a vast array of styles, subject matters, and genres for every age range, from early-learning interactive books featuring shapes and colors with simple text, to picture books and pop-ups. Children's book illustration differs from other forms within the discipline in that many publishers commission artist and author at the same time; in some cases, artist and author are one. Developing the text and images for characters and storylines is often an inclusive, collaborative process between artist and author.

Illustrators must be mindful of the connotations of, for example, different colors within different cultures; understand their responsibility to portray the ethnic mix of today's society; avoid creating gender and racial stereotypes; and be aware of the emotions their images might inspire. Illustration, as a hugely creative part of the children's book, holds a unique responsibility for the visual representation of the best-loved and most memorable characters from our childhood.

Both imges:
Educational books
Pencil
For *Do Not Open*, a book about secrets from around the world, Hennie Haworth created a multifaceted image in response to a chapter entitled "Kremlin Secrets." In another educational book, published in Japan, Asako Masunouchi created illustrations about the importance of money for "Osatsu no Johnny" (A banknote, Johnny).

Album sleeves and music posters

Art school and popular music have always gone hand in hand, with art schools a hotbed of musical as well as artistic talent. Most successful contemporary bands have a family tree with branches that include artists-turned-musicians. Many popular groups, from every decade since the 1960s, have their roots in the art-school experience.

Inextricably linked, artists and musicians have a healthy respect for each other's disciplines. It is not uncommon for the graphic image of emerging bands to have been created by one of the lineup (often a current or former art-school student), or a close friend of the group (most often an art-school acquaintance rather than a professional designer or illustrator).

Bringing a visual form to music is a challenge. Music graphics and illustration have played a definitive role in shaping the way we relate to a band's musical output, creating a tangible identity and personality for the product. Many prolific music designers and illustrators found their creative calling through listening to music and studying the sleeve artwork.

Album cover and label
Digital
Simon Dovar of Simple Shape used a single concept through a set of 12in singles for Manuel Tur on Freerange Records: he removed the object the figure on the cover is interacting with and placed it on the central label of the record itself.

 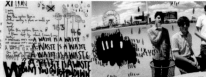

Album cover and promotional artwork
Pen, pencil, collage, mixed media
Chris Wright, aka Tinhead, created the artwork for every format of the Foals' release *Antidotes*, including packaging for a four-track sampler, the album Digipak, the CD and DVD inner sleeves, and sticker sets. The toughest aspect of the commission was making the album artwork recognizable as a 20 x 20mm (1 1/16 x 1 1/16 in) icon for iTunes.

Below:
Record covers
Mixed media, collage
SIC Recordings, an
underground record label,
commissioned Martin O'Neill
of Cutitout to create this
multipurpose sleeve for all
its 12in vinyl releases.

Album covers
Pen, pencil, digital
JAKe has created numerous
sleeves for Prince Fatty, on
Mr Bongo records. Two of
these featured hand-rendered
letterforms inspired by reggae
lyrics. Bold, flat colors give
the campaign a distinctive
graphic feel.

Despite the established relationships between musician and artist, the future for music graphics is unclear. With CD sales falling, the single and album sleeve appears less crucial to the marketing of music products than ever before. Live music, however, has never been more popular, and the sale of music-related merchandise—T-shirts, tour programs, gig posters, and button badges—is on the rise. Digital music downloads continue to rise as bands, stepping away from traditional record-company representation, provide video clips and animations as content for their own websites, MySpace sites, micro-sites, and blogs, and for cell phones, video showreels, and TV commercials. The ways in which we enjoy and consume music continue to alter, and the role design plays remains in flux.

Where once designers and illustrators could concentrate solely on high-profile sleeve art, the challenge for tomorrow's illustrators will be how they adapt to these changes, while continuing to create iconic, memorable, and diverse images.

Poster/Screen-print tribute
Screen print
This limited-edition screen print, by Austin at NEW, was created in honor of Michael Campbell, aka Mikey Dread, a pioneering Jamaican-born musician, recording engineer, producer, and DJ.

Album cover
Pen, collage, digital
Chrissie Abbott's work
for Philadelphia-based
psychedelic band The
Asteroid No.4 typifies the
resurgence in beautifully
crafted image-making,
merging hand-drawn and
photographic elements.

Left:
Gig poster
Digital
Chris Watson captures
the sound and spirit of the
Legendary Shack Shakers
through his use of hand-
rendered type and simple
linework in this gig poster.

Right and below:
Album covers
Pen, pencil, digital
Dan Mumford, illustrator and
designer, creates intricate
images that reference folk
stories and include elements
of fantasy. For band Callahan,
Mumford created a monster
to represent struggles
within a relationship, while
for Gallows he visualized
wolves and sharks.

Posters and prints

Posters hold a special place in the heart of many illustrators and designers. Part of their appeal lies in their size and the nature of their display—a poster occupies a greater physical space than a book, album sleeve, or editorial illustration—but it is other aspects of a poster's physicality that have made such a lasting impression.

Since 1870, with the perfection of color lithographic techniques, posters have been used to promote, inform, and persuade. Even now, in our digital age, posters often form the basis of an advertising campaign, are routinely used by retail outlets to promote products and fashion, and by clients across the arts and cultural sectors

to promote theatrical shows, and exhibitions at galleries and museums. They remain a dominant feature of the urban landscape. Despite the proliferation of photographic poster solutions, illustrated posters maintain a link with their illustrious past; illustrators enjoy the challenge of the format and the heritage associated with it.

Poster map
Digital
Steve Lawler designed this poster map to represent the religious demographics of Singapore. It was displayed as part of Dual Cities sessions at Designtide Tokyo.

31% Taoist
28% Buddhist
18% Muslim
10% Christian
4% Hindu

Promotional poster
Digital
Japanese illustrator Amore
Hirosuke based this poster,
part of a promotional
campaign for the Japanese
illustration agency CWC,
on a Miami diner.

Posters have a strong association with underground movements, with counter-culture and the avant-garde. Low-fi print techniques, such as screen printing and the use of photocopiers, along with cheap digital output options, have created a resurgence of interest in illustrated posters. Many illustrators are now creating prints and posters as artworks in their own right, for self-promotion, and to promote exhibitions of their own artworks, 'zines, and products.

This upsurge in self-published and limited-edition posters, rather than working to a brief, gives illustrators the freedom to push the medium, and the exciting work this generates gathers new advocates of this vital discipline within illustration.

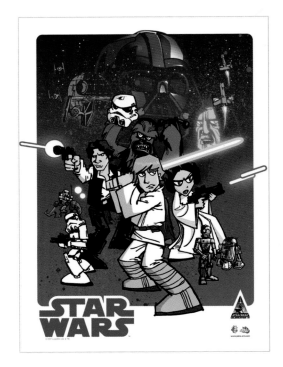

Above left:
Commemorative poster
Lithographic print
JAKe was commissioned by
Lucasfilm Ltd to design and
illustrate this *Star Wars* 30th
anniversary poster.

Left:
Large-format poster
Pen
Habitat, a homeware chain
in the UK, commissioned Hennie
Haworth to create this image,
Skyline of the World, to be
reproduced as a large-format
poster, printed on canvas.

Above:
Promotional poster
Ink
For Cartoon Network, Dr. Alderete
created this giveaway promotional
poster based on the characters
who make cartoon wrestler
Santo's life more interesting.
Bold and bright, it is a poster
with instant appeal.

Corporate

Commissions from corporate clients generally aren't as plentiful or regular as editorial work, they don't offer as much creative freedom as music-related work, and don't demand the understanding of narrative that publishing work requires. With corporate work generally less well paid than advertising, what's in it for the illustrator?

Corporate illustration commissions vary widely. An illustrator might be asked to make works for business-to-business clients, creating images that may never be seen by the general public—perhaps a series of illustrations for a company's annual report for shareholders, or for in-house brochures or publications sent solely to other businesses. A company's marketing literature might require the use of illustration, as may their financial reports.

While the remit for the illustrator might appear relatively broad, a clear characteristic of corporate commissions is that illustration is introduced to make a "dry" subject appear more interesting. It is used to add visual sparkle, to create a more interesting identity, to make an overall project more dynamic.

Within corporate design, illustration may need to communicate complex messages: some projects demand images that detail specific facts; others require images that are more thought-provoking. Many projects, however, demand nothing greater of the illustrator than creating a purely decorative feature, providing some much-needed visual respite from facts and figures. And this, in itself, can be the challenge—creating images that, even without an opinion to voice or a story to tell, express a personality.

Walkway wall
Mixed media, digital

Imperial College, London, commissioned Studio Tonne to create a series of panels for a new walkway wall. The college was keen for these panels to communicate aspects of how scientists have recorded their ideas and analytical thinking, and the results of their research, in notes. This project is a fine example of corporate design with integrity in an architectural space.

Mural
Pen, digital, vinyl graphics
Richard Hogg created this
image for Acknowledgement,
a London-based digital agency.
It was used on the company's
promotional materials, and
as a mural in the office foyer.
Hogg's visual brings a warmth
and quirkiness to the brand.

Company stationery
Pen
Children's TV channel
Nickelodeon commissioned
Hennie Haworth to make
a series of drawings that
could be used across the
entire range of the company
stationery. Haworth's doodle-
like images display a wit that
reinforces Nickelodeon's
brand values.

Press

Advertising, more than any other strand of the visual communications industry, needs to constantly change the methods it employs to communicate with its audience. Illustration has enjoyed a long association with advertising. It first appeared as simple black-and-white line art in newspaper ads, and was most often used to give a visual representation of a product in the years before print technology allowed photography to be used in this way. As color print became more freely available, posters advertising products and services used illustration in more creative and eye-catching ways, but illustration's popularity waned as photography came to be perceived as the purveyor of "truth," as a more real representation of a product. Illustration's role has been to bring personality to a product and to help infuse a brand with a particular identity.

The primary role of an advertising agency is to promote and sell products on behalf of its clients—mainly major corporate

BEARDYMAN

When beatboxer extraordinaire Beardyman, is not laying down mad vocal effects moments before the likes of Groove Armada hit the stage he's somewhere else. "I like to go to all sorts of club nights," the twice UK Beatboxing Champion smiles of his late night liaisons. "I'm a bit of a drum & bass head, but I like all sorts. I've also been known to go to hands in the air house nights. I can be loud, especially when drunk," he jokes. "I woke up the other day on an empty tour bus, to find I was wearing a t-shirt with 'Nobody knows I'm a lesbian' on it."

"I never like hearing that my girlfriend's got an illegal cab home on her own," he reveals his fears: "She shouldn't do it. I lost a suitcase in one once with a grands worth of music gear in it. I tried to trace it but I didn't get a number plate so there was no chance: a sobering lesson in the lack of accountability of unlicensed cabs." And of Cabwise his views are clean cut: "I'll be giving that number to my girlfriend."

GETTING HOME SAFELY

Text HOME to 60835 to get one taxi and two local, licensed minicab numbers sent to your phone.
To order a taxi call:
● One Number taxi bookings 0871 871 8710
● Zingo (from a mobile ONLY) 08700 700 700
For train information

and timetables call 08457 48 49 50 or visit www.nationalrail.co.uk
For information on
● Bus and night bus routes
● Tube timetables
● Minicab phone numbers
● Minicab licences
Call 020 7222 1234 or visit www.tfl.gov.uk

AS 'C TO YOU

Don't risk taking phone numbers s minicab. When you are in Lond 60835 and you'll minicab numbers

Texts charged at 35p per en available on Virgin and 3 mob this and for access for tourist

companies. In order to do this successfully it must find innovative ways to reach and appeal to an audience that can, at best, be described as fickle, and that has the power to flick through TV channels, tune from one radio station to another, and refuse to click on web banner ads.

Across the various aspects of traditional print media, press advertising is well placed to communicate with particular types of consumers; agencies and clients recognize the value in placing their product in front

Press campaign
Pen
This press campaign for the Greater London Authority's Transport for London was designed and illustrated by Billie Jean. The aim of the campaign was to promote safer travel at night for women in London.

SWAY
"I like going to clubs like Movida in London and LoveDough up in Newcastle," Sway, of Dcypha Productions and This Is My Demo fame clarifies: "When I go to clubs I'm usually in the VIP section. I don't mind being in amongst it – I mean I don't sit in the VIP all the time – just sometimes I just don't want to be bothered. I'm usually the quiet one in the group, especially as I don't drink." Of the true stories involving crooked cabbies, the north London resident exclaims: "I think it's disgusting, I mean for someone to take advantage of girls or attack people... girls really need to be careful. They need to be thinking, 'How am I going to get home?' When I see drunken people on the street standing around on their own and waiting for taxis, it makes me wonder. 'What is she/he thinking?'" Sway adds getting in a dodgy dude's cab is: "the equivalent of wearing a 50 grand chain, walking through Tottenham and not knowing anybody there. You're basically asking for it. You've got to use your brain man."

MAKE YOUR JOURNEY SAFER

When travelling by taxi or minicab, remember:
• Only use a licensed taxi or minicab.
• Only taxis can be hailed in the street; minicabs must always be booked through a licensed minicab operator.
• Unlicensed and unbooked minicabs are uninsured.
• When you book your

minicab, ask for the driver's name, make and colour of vehicle.
• When the driver arrives ask them to confirm your name and destination – make sure it is the taxi or minicab you ordered.
• Try to share with a friend and sit in the back with your phone switched on.

VISE'
E NOW

abwise texts you
a taxi or licensed
home, wherever
word HOME to
wo local licensed
ur mobile phone.

ge rate. Service not currently
www.cabwise.com for news on
etworks soon (Christmas 2007)

Z-CARD® Ltd. PTN
information to go here

of the specific audiences that particular newspapers and magazines attract, and can target their marketing accordingly.

However, successful marketing strategies demand more than just well-considered advertising placement. In today's consumer society, the personality of the brand, and the consumer's relationship to it, is all-important. Brands differentiating themselves from their competition by creating a unique stance has become a vital aspect of marketing. This has allowed illustration to reestablish itself as an important part of advertising, a field that has, in recent decades, been dominated by photography.

The use of illustration within an advertising campaign usually signals strong brand confidence. For a brand seeking to position itself as outside the mainstream, a little quirky perhaps, illustration can offer the right balance of individuality and personality. Editorial illustration, certainly within news-papers, is usually associated with humor (due to the close relationship illustration has with cartooning), or signifies a strong opinion or point of view. When illustration is used within press advertising, many of the same associations come into play: individuality, quirkiness, a point of view, and a sense of humor.

Advertising agencies, and increasingly brand consultants, provide companies and their products with the opportunity to harness many of illustration's particular attributes. Illustration looks and feels real, genuine, authentic. It also has an expressive, emotive quality—the personal visual language of the illustrator becomes the brand's visual signature, and close

associations are made between the illustration style and the product. For this reason, many agencies seek contracts preventing an illustrator from working for competitors within their market sector.

However, it is rare for a brand, and especially the agency behind a brand, to remain faithful to an illustrator, or even a style of illustration. Illustration is still viewed as a means for a mainstream company to promote products that they wish to appear whimsical or irreverent; its allegiance to illustration may be as fickle as the very audience with which it is hoping to communicate.

Left:
Magazine ad
Pen
Upbeat and humorous, this full-page ad, illustrated by Hennie Haworth, promoted South African fashion label Meltz in fashion magazines.

Right:
Magazine ad and poster
Mixed media
Used as part of a full-page ad and for a poster campaign for Robinsons, Adrian Johnson's Orange Boy is a simple idea beautifully executed.

THE WORLD
SHOULD BE
YOUR OYSTER

NOT A CLAM ●

Left:
Magazine ad
Paint, ink, pencil
For a full-page ad in
Economist magazine,
Paul Davis created a bold
and eye-catching image
designed to stop readers in
their tracks, and make them
contemplate its message.

Far left:
Press ad
Digital
Mimi Leung's press ad for
the Orange YCN Creative
Awards 2008 is optimistic
and colorful in equal parts.

Outdoor

The term "outdoor advertising" generally covers posters of varying formats, from those adorning bus shelters and other small sites to large, 48-sheet billboard posters. Outdoor advertising tends to work in a proactive, attention-grabbing manner: communication of a message to an audience on the move has to be bold, and the message must be read and understood instantaneously.

All ad campaigns require input from a myriad of ad-land creatives and suits. The illustrator is just one player in the game. Even a simple-looking visual solution will have gone through many stages on its way to being realized. The initial briefing for the project may have been conducted by a team of account handlers meeting with the client, often in the presence of the creative director who has overall responsibility for the project. It is likely that a creative team consisting of

an art director and copywriter will then be assigned the project, reporting to the creative director and communicating with the client through an account handler. The creative team may bring in the services of an in-house art buyer when they have reached early decisions about the visual route the ad might take. Art buyers are charged with finding the right creative person for a project, whether that be a freelance illustrator, photographer, model-maker, stylist, model, web designer, or any other professional the project may require. In-house typographic designers may work on the ad next, to breathe life into copy created by the copywriter. Visualizers will then mock up ads for presentation meetings with the client. Before large campaigns go into production there is usually some market testing undertaken, and while the creative work is ongoing,

All images:
Press ads
and posters
Pen
The Samaritans wanted to increase young people's awareness of their existence, and of the help they could offer. The results of focus groups revealed that a doodle style of illustration best represented the emotional state of young people who could benefit from their support, so the Samaritans commissioned Billie Jean to create relevant illustrations in this style. The campaign was run as press ads and outdoor posters.

Things on your mind? 08457 90 90 90 jo@samaritans.org

SAMARITANS

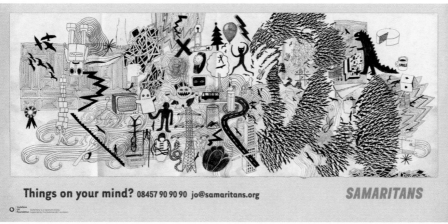

Things on your mind? 08457 90 90 90 jo@samaritans.org

SAMARITANS

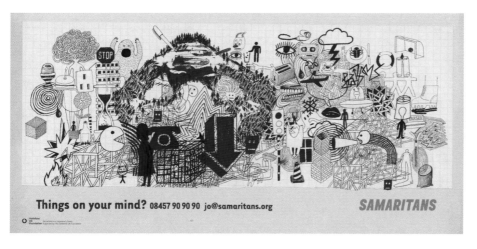

Things on your mind? 08457 90 90 90 jo@samaritans.org

SAMARITANS

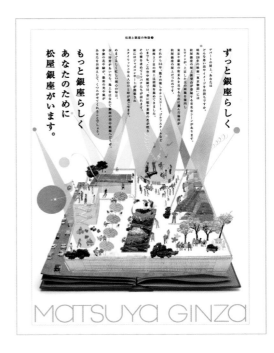

media planners and buyers are making
decisions on where best to place the ads,
and purchasing media space. Production
teams are working on details to ensure
that all required formats will be catered
for, liaising with production companies,
printers, and the companies that manage
the poster sites.

While the illustrator is just one player
in this team game, and certainly not the
captain, he or she takes huge responsibility
for the visual aesthetics of the final ad—
after all, the illustrator has often been
selected for his or her personal style,
and this becomes inextricably linked
with the product.

While working for advertising agencies
can be financially rewarding, it may not
always be creatively so. There is a widely
recognized axiom—the more money, the
less artistic control. With high-profile
campaigns to create, direct, and produce,
advertising agencies are under pressure
from their clients to get results. To succeed
in advertising, an illustrator must first
understand their role in the overall process.

It is easy to feel overwhelmed by the
mechanisms that agencies employ. A never-
ending series of meetings between creative
department, account handlers, and client
cut into the illustrator's creative time, and
often seem to quash any opportunity for
experimentation. Advertising art directors
will map out, sometimes in intricate detail,
the direction the artist must take—the
illustrator is there to bring an art director's
creative vision to fruition.

Despite the frustrations that can be
experienced working for advertising agencies,
this arena presents an undeniable challenge
and a genuine appeal. The strict confines of
the format for bread-and-butter commissions
for a magazine page or a CD sleeve can
be cast aside when creating an image that
might be reproduced across a billboard
poster and seen nationally, or even
internationally, by an audience of millions.

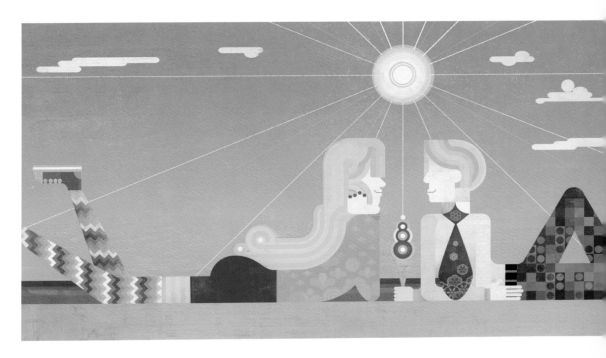

TV, web, e-mails, and cell phones

The use of illustration in advertising isn't restricted to the static printed image—TV campaigns have utilized illustration for decades, and as communication channels diversify, opportunities for illustrators continue to expand. Advertising has always explored new avenues. Since the turn of the twenty-first century, advertising on the web via banner ads, targeted marketing based on user profiles, and online games and promotions have all become prolific. Advertising onto cell phones and other formats via viral e-mails has also become part and parcel of the advertiser's armory.

The birth of film ensured that the moving image became a logical progression for many illustrators. While animation remains a distinct discipline, often taught separately from illustration within art schools, many illustrators find their creative calling working with sequential narratives, and advertising can often be the catalyst in this process.

Advertising agencies, keen to adopt the latest trends and styles, have often been instrumental in bringing together illustrators and animators to create campaigns for TV. Art directors in agencies, on the lookout for new ways to communicate the USP (unique

selling point) of their clients' products,
or simply wishing to stay ahead of the
curve stylistically, have sought illustrators
whose work lends itself to quick, sharp,
animated storytelling.

Opposite and below:
Online and in-store
promotions
Digital
Berto Martínez's images for
Zara, the Spanish fashion
retailer, were created for the
company's online presence
and its in-store promotions.

From TV screen to computer screen, illustration has played its part, and the pioneering days of advertising on the web also saw illustration enjoying a significant role. Prior to fast connection speeds, upload and download times were crucial, and small-file, Flash-based animated gifs were the most-used format for creating motion graphics for the web. Moving-banner ads have become increasingly sophisticated as high-speed broadband access has become the norm, allowing file sizes to increase.

With Wi-Fi access more freely available than ever before and cell-phone companies offering 3G networks, phones have become a mobile all-in-one—phone, organizer, e-mail device, and web browser—making them the latest media device through which advertisers can reach their audience.

In a bid to maximize response rates, advertisers are finding new ways and means of targeting their potential audience more precisely. For the first time, companies are able to promote specific products to specific customers.

User profiles that include information about preferred music, movies, fashion etc., on social networking sites like MySpace, Facebook, and Bebo, are constantly trawled for keywords by advertisers wanting to build campaigns around the perceived interests of the individual user. Illustration is one means by which companies can create a dialogue with their customer that feels friendlier, warmer, and, of course, far less corporate than other means of communication.

It is no surprise that many cell-phone companies have used illustration in their own campaigns in recent years. Understanding how a viewer perceives a set of images sent to the screen on their cell phone, or how an animated banner ad on a website can attract the attention of a user, is fundamental for illustrators wishing to work across media. The illustrator's blank canvas is constantly evolving, and only those who evolve with the technology will remain current, contemporary, and, most importantly, employable.

Digital greeting card
Digital
This is just one of a set of characters created by Simon Oxley for a web-based, digital greeting card company.

Left:
Viral promotion
Pen, digital
The Arusha Accord commissioned Dan Mumford to create an image for their online viral campaign. The brief was for an abstract design with an element of an undersea world.

Right:
Viral campaign
Digital
For the promotion of the Big Daddy Box Meal in the youth market, KFC's advertising agency BBH created a viral, web-based game, illustrated by Serge Seidlitz.

Retail

Advertising appears to have permeated every aspect of contemporary living, and so too has the modern retail experience. Recognizing this, brands have used promotional techniques that merge every aspect of the retail experience, from in-store design and decoration echoing a current ad through to shop windows being used to display print campaigns.

Retail design and promotion, just like advertising, has plundered the creative industries in search of new talent and visual styles to provide the voice for promotional concepts. This is particularly true of the "lifestyle" market sector, whose customers are often ahead of the curve in terms of street fashion, technology, and music, and are increasingly tricky to market to: they want to appear to be *leading* trends rather than following them. Smarter brands understand the importance of getting this type of consumer on board, yet also comprehend that straightforward "buy this" strategies don't work with these potential customers. Brands look for other ways to make their mark, often choosing to align themselves with a particular artist because of their reputation and the associated kudos that will come from the relationship.

Some brands set aside spaces within their retail environments for prominent artists to design, decorate, and illustrate in return for the "halo effect" of being associated with a cool name. Other brands commission big-name artists to create press and poster campaigns.

Left:
In-store promotions
Vinyl stickers
Melvin Galapon worked with fashion retailers Size and Urban Outfitters to create in-store promotional campaigns by applying vinyl graphics directly to walls and display cabinets.

Right:
In-store graphic
Pen, pencil, ink, digital
For sports fashion brand Roxy, Japanese illustrator Chico Hayasaki created this optimistic window graphic for the Summer season, entitled La La Sunshine.

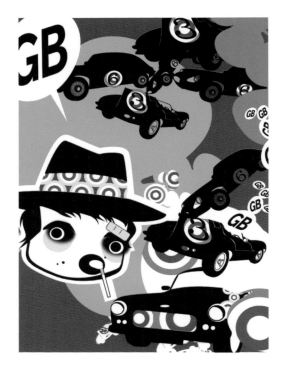

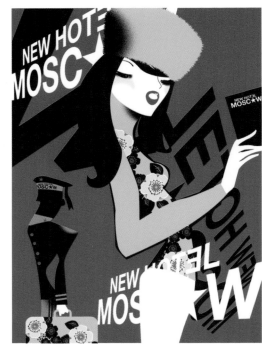

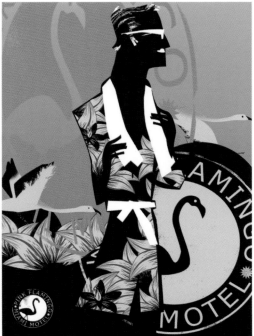

Retail posters and in-store graphics for cool brands represent an interesting creative conundrum for illustrators who exist within a more underground culture, operating on the fringes of what might be considered cool and current. These illustrators are at least as conscious and critically aware of contemporary culture as the consumers they need to reach—what is the average shelf life for an illustration style applied to a particular brand, when the dictate is that of constant change?

All images:
In-store posters
Digital
Jorge Arévalo worked on a campaign of in-store posters for high-end fashion retailer Custo Barcelona. The themes of the campaign were cosmopolitan lifestyles and boutique hotels.

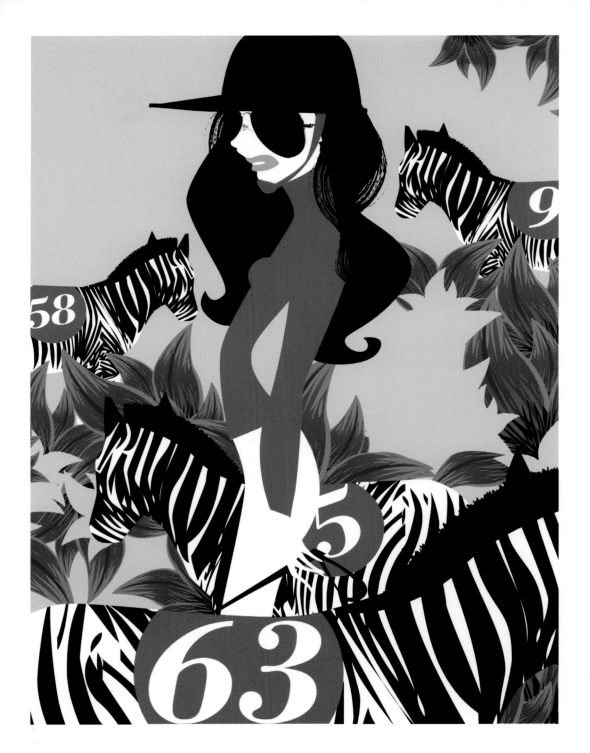

T-shirts and apparel

Fashion and illustration have strolled hand in hand since the heyday of fashion illustration in the 1930s. However, despite a steady decline in the use of illustration within fashion magazines (photography began to replace it in the 1950s), it remains very much part of the creative process for fashion designers themselves. Illustration is used primarily to visualize looks, styles, fabrics, details, etc., before garments are made. Fashion illustrations are as individual as the designer and the clothes they create.

In fashion today, opportunities for illustrators are often limited to designing patterns or images for textiles and garments—the classic printed T-shirt continues to offer the most potential. Originally a defining image of rebellion, the T-shirt is now an essential item for every wardrobe. Worn by all, T-shirts have become the primary medium of identity for youth, students, music lovers, movie fans, and sports enthusiasts.

Whether it is a commission for a fashion house, a promotional device, or a self-initiated project, the T-shirt has provided a blank canvas for illustrators since the 1960s. In recent years illustrators have found routes into designing, printing, and marketing their own ranges, many creating online stores as an adjunct to their online portfolios. Retail stores have also entered the field, inviting artists to submit designs for approval and rating by their peers in order to produce and sell those winning the most votes.

The desire to decorate doesn't stop with the humble T-shirt. Illustrators use every opportunity to bring their work to a range of different media including skateboard decks and sneakers, bags, toys, and other accessories. It would appear that very little escapes the hands of illustrators seeking to bring their work to new audiences.

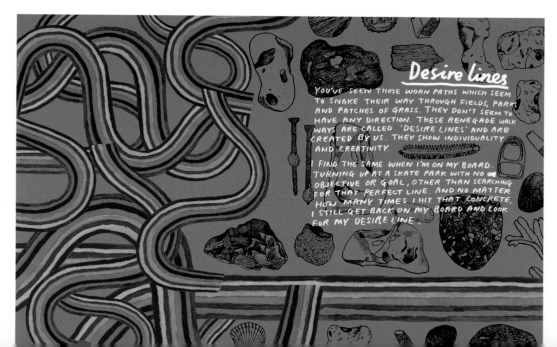

Right, above and below:
Skate decks
Digital
Andrew Groves of
IMAKETHINGS designed
a limited-edition deck
for its F-art series, and
a range of decks for
Foundation Skateboards'
pro team, based on the
team's riders.

Left:
Fashion illustration
Acrylic paint, ink
Billie Jean's illustration for
clothing company Howies
typifies the company's
left-field approach to the
marketing of their products.
The design is based on
a poem by a skateboarder.

Creativity Reigns.
fenchurch

Above:
T-shirt
Digital
Junichi Tsuneoka created this
limited-edition (available for
one day only) T-shirt design
for fashion label A Better
Tomorrow (A-B-T).

Top right:
T-shirt
Digital
Colin Henderson based this
repeat-pattern T-shirt design
on scorpion tails.

Left:
T-shirt
Digital
Adrian Johnson's T-shirt
design for Fenchurch
illustrates the never-ending
push of London's financial
district into the East End
artistic community.

Left:
Tote bag
Pencil, digital
Jawa and Midwich designed
this canvas tote bag for Pan
Macmillan as a promotional
item for the ethical treatment
of books. Their hand-drawn
illustrations explore the
unusual treatments of books.

Self-promotion

Illustrators are solo workers, called in when a project or commission demands their attention. While they often share studio spaces and form partnerships, collectives, or companies, most work as sole traders, competing with other illustrators for the work available. Illustrators have varying methods for finding potential clients and making industry contacts, but common to them all is the pressure of being constantly in search of work.

While this may seem a highly romanticized view of the life of an illustrator, it is based on reality. Illustrators rarely take, and are rarely offered, full-time jobs, and while many are happy to hand over all responsibility for finding work to an agent or rep, there is still a strong underlying pressure for freelancers to be aware of their own job sheets. Along with being their own bosses, they are also their own head of marketing. With no job security, strong marketing and promotional techniques can make or break them.

The most gifted and talented rookie may never get the opportunity to prove him- or herself without a commission, and a commission will certainly never arise if clients remain unaware of the illustrator's work. For the freelancer it is as crucial to understand the art of self-promotion as it is to understand the art of illustration.

Personal work
Screen print
Monica Aichele created How to Make Snow! as a promotional card to send clients. The beautifully crafted cards were screen printed, giving them a far more individual feel than digital print.

Personal work
Mixed media
Christina Koutsospyrou creates screen prints and mixed-media illustrations about contemporary fashion and culture. Represented in New York, she created this self-promotional image to showcase her drawing and textile design talents.

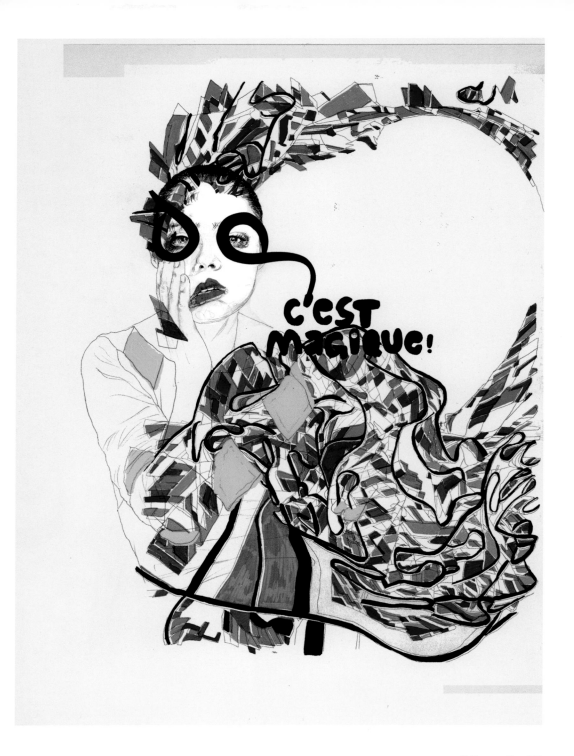

Personal work
Pen, pencil, collage
The oddest ideas can surface in self-promotional work. Tonwen Jones based this image on the idea of Japanese chefs looking for substitutes for tuna, due to diminishing fish supplies.

Portfolios

Illustration is constantly evolving. The work shown here reflects the radical shifts in practice of recent years. Technology has played a crucial role in the development of each and every portfolio in this section. Working methods merge and mutate as the analog and the digital overlap, and at the same time studio practices evolve as illustrators adopt new business models. Normal service, epitomized by the solo illustrator represented by a major city-based agent, will not be resumed. Illustrators are moving to business models once reserved for design agencies. Solo practitioners, admittedly still the greatest in number, have been joined by those who work in duos and small teams, mixing illustration and design skills to great effect.

MAKI in the Netherlands and Gluekit in the US are two examples of the recent phenomenon for small design/illustration studios. Other, larger groups present themselves to the world as united businesses. McFaul in the UK and Vault49 in the US both promote themselves as companies rather than freelance illustrators. The work they produce is diverse—not for them a single visual language—though each manages to create its own distinct brand, with sub-brands and styles existing within an overarching house style. Increasingly, clients are commissioning a studio or company rather than an individual illustrator as this makes it easier to develop a portfolio of styles: a studio, unlike a solo illustrator, can bring in new illustrators and image-makers to add to the mix.

Another successful business model is that of Peepshow in the UK, a group of 10 illustrators all working under their own name as well as under a collective studio identity. eBoy's three illustrators work under one name, and while they choose not to work together in one studio, all three are capable of producing imagery that looks like the work of one studio.

Illustrators have embraced the web as a means of communication. Able to interact more freely with one another and to discuss commissions, projects, techniques, and working methods, they are now more aware of the work of their international peers. A healthy respect for interesting trends and fashions in image-making is evident. Illustrators are competing to make the best work not just for their clients, but also to

display in magazines and journals. The web has enabled design companies, advertising agencies, book publishers, newspapers, and magazines to look further afield for illustrators, and many artists now market their work internationally. With the time needed for delivery of artwork down from days to minutes, an illustrator can work with clients anywhere in the world.

A growing trend has seen a number of commercial artists relocating: Christoph Niemann from Berlin, Vault49 from London, and Stina Persson from Stockholm have all set up in New York City, continuing to work successfully with clients in Europe while embracing work for US companies as well. Other illustrators spend much of their lives in the air. Fans demand that Jeremy of Jeremyville, located in Sydney, and :phunk studio, based in Singapore, appear at shows, talks, and events around the world. Spending so much time away from their home and studio has meant that Jeremy and :phunk studio have had to develop working practices that allow for constant long-haul travel: they brainstorm projects, sketch visuals, or refine artwork on a laptop in the air.

fashion illustration runs through Stina Persson's veins. She studied Fashion and Fine Art in Italy before embarking upon an illustration course at the Pratt Institute in New York, returning to her native Stockholm, Sweden, in 2003 after nine years Stateside. Fashion may be an obvious interest, but it is not the only subject driving Persson's approach to creating images. "I like making things," she admits, "be it walnut bread or paper dinosaurs for my kids. Illustration allows me the constant challenge of making something beautiful. I like that aspect."

Persson has become a truly international and in-demand artist. "Being an illustrator I get to make things, and I am constantly solving problems. This suits me. That I get to work, living in Sweden, for clients everywhere from Mexico to Japan and New York to Delhi is a huge benefit." On top of commissions for her international client base, Persson's artworks have been featured in design magazines around the globe—a clear indication of the popularity of the beautiful images she creates.

The appeal of Persson's images is as much about the models as the garments. "I always want the people I paint to look interesting, to have a gaze, to be people rather than fashion drawings," she explains passionately. "This isn't always popular as many clients fear the personal and want something stylized. And yes, I don't do smiles!" she adds.

Running a frenetic studio and bringing up a young family with her journalist husband, Persson understands the pressures of working for clients within the creative industries. "Illustration is about

work being made to order," she explains, "with deadlines, specifications, and a client to satisfy. Under those circumstances, to make something spontaneous, beautiful, and with a soul is the challenge. It might sound easy and trivial," she adds, "but it is an art form in itself."

Exhibition pieces
Ink, watercolor
Persson's ability to represent
the female form relies not only
on her stunning drawing skills,
but also on effective editing.
The beautiful simplicity of
these ink-and-watercolor
portraits for an exhibition
of work entitled La Femme,
shown at Gallery Nucleus
in Alhambra, Los Angeles,
shows her capacity to say
so much using so little.

Left, top and bottom:
Magazine feature
Watercolor, photograph,
digital
Muse magazine, based
in Milan, opt to mix still
photography and illustration
in every issue, lending
a more artistic approach
to showcasing new fashion
accessories. Persson worked
in watercolors over digital
photographs supplied in
Photoshop, cleverly mixing
her images into foreground
and background, twining
plantlike patterns and forms
around the products.

Above and right:
Magazine feature
Watercolor, photograph,
digital
For *Codigo 06140*, published
in Mexico, Persson worked
with fashion photographer
Fabiola Zamora to create
these images of model
Sabine. The combination
of the photographic and
abstract illustrated marks
created a new visual
language for illustrator
and photographer.

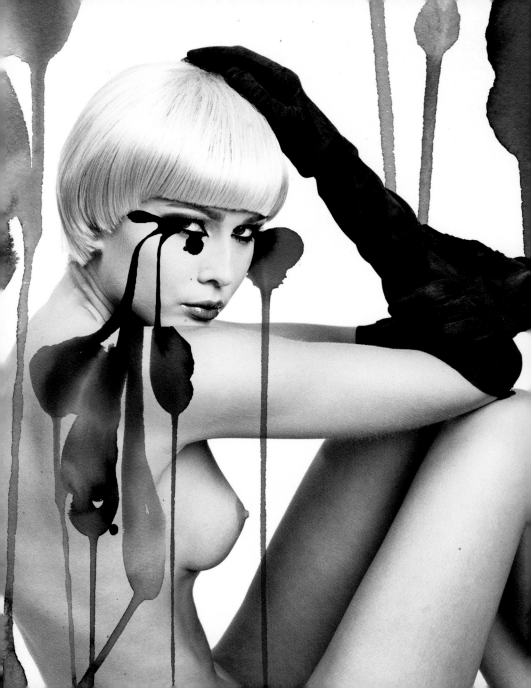

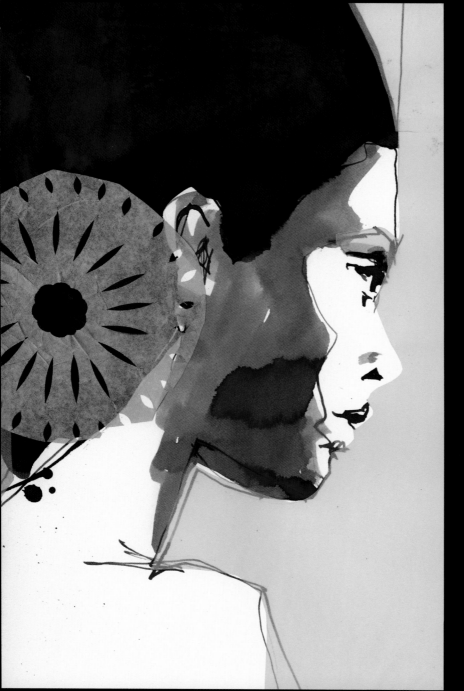

Exhibition pieces
Ink, watercolor, paper
For a solo exhibition at gallery hanahou in New York, Persson created a series of images based on the dramati names typical of southern Italy. The illustrations in Immacolata and her Friends were inspired by Persson's regular trips to Italy, and created using a combination of inks, watercolor paints, and cut paper.

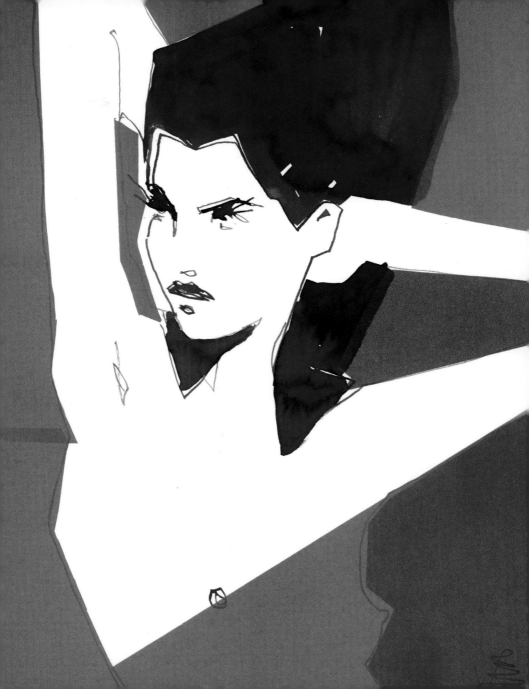

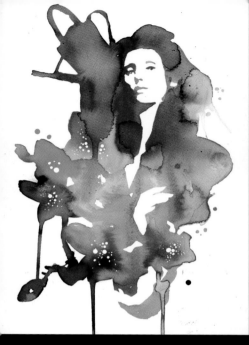

Above left and right:
Magazine feature
Watercolor, digital
Frau magazine, published
in Japan, commissioned
Persson to create a full
set of horoscope images:
Sagittarius and Leo, shown
here, are part of this set.
The brief required that the
illustrative approach embody
elegance and sex appeal,
and that particular elements—
lace and tiny flowers—be
incorporated into the images.
Persson's abilities allowed her
to meet all of these criteria,
and at the same time stay true
to her creed "less is more."

Right:
Annual report
Watercolor, photograph,
digital
This illustration was
commissioned for PP
Pension's annual report.
The striking juxtaposition of
an abstract watercolor paint
drop with a stark photograph
of a tree creates a visually
arresting graphic image.

Christoph Niemann

"I'm a graphic designer at heart. I understand that different problems require different treatments, and that the mantra 'form follows function' is going to save my ass one day," says Christoph Niemann, a passionate advocate for ideas-centered, problem-solving illustration. Niemann trained in graphic design at Stuttgart Academy of Fine Arts in Germany, moving to New York upon graduation in 1997 to begin a career in illustration, working predominantly as an editorial illustrator.

"Despite studying graphic design, I majored in illustration," Niemann admits. "I had a harsh tutor, but it was a fantastic education." The harsh tutor was no less then Heinz Edelmann, art director and illustrator of the 1968 classic Beatles movie *Yellow Submarine*.

It was this education that set Niemann on his path to concept-led illustration. "I have a real problem with illustration that isn't created within the context of graphic design," he continues. "Being an illustrator is like being an artist without being an artist; it is not about self or ego, it is always about collaboration and compromise." Niemann understands the complexities of working to a brief, for a client and for an end user or "reader," as he refers to his audience. "For an illustrator, the collaboration with a good art director means that it is never just about making a picture to fill a white space on the page—an art director will always have an opinion," he explains.

Niemann's favorite clients are those that push him and demand the best of his skills because they also care passionately about the quality of the work and the strength of the message. "*The New Yorker*, for me, is the Olympic Games of illustration commissions. Your illustration takes center stage, no cover lines or text, just you out there for a week—your idea, your work, and nothing else," he states. "And the readers are demanding too." It is the end user who is at the core of Niemann's drive to create work. "It's all about the reader," he exclaims. "If you design a sign for a bathroom, it is all about helping someone find the bathroom. It's the same with a funny idea; it's not for you or the art director to laugh at, it's the reader who should be laughing. If they don't laugh, you have failed."

Niemann often wonders at what he does and how it all happened. "I'm like a kid at a candy store," he admits. "I do exactly what I did as a 13-year-old, the only difference is I get paid for it now. I have an amazing freedom." The freedom, however, could be short-lived. "In three days' time I could be out of a job. I have work until the end of the week," he states. "And it is always like this. I've gotten used to it, but there really is no sitting back and relaxing. I do sometimes wonder what it would be like to just go into an office and work through a pile."

Magazine cover
Digital
This cover image for *The New York Times Book Review* sits alongside a review of *Exurbia*, in which David Brooks explores the phenomenon of urban sprawl in the USA.

Niemann, after 11 years, is leaving New York for Berlin, keen to explore new influences and inspirations and to connect with his German past. He insists he'll still work for his US editorial clients, despite the pressure of the frantic deadline. "Editorial work is crisp and fresh," he insists. "It's too fast to get stale. There is no time for slow-cooking an idea, and if a solution stinks, it only stinks for the life of the newspaper or magazine." It is evident that Niemann's timeless illustrations remain as fresh as the day they were executed.

Above:
Magazine cover
Digital
An editorial illustration for *Wired* magazine, published in the USA, that accompanied an article discussing the pros and cons of deleting negative comments posted by readers of your blog.

Opposite, top left:
Magazine cover
Mixed media, digital
For a Fall issue of *The New Yorker*, Niemann created this cover image. His trademark simplicity marries creative thinking with artistic execution beautifully. And once again, the image says it all.

Opposite, top right:
Magazine cover
Pen and ink, digital
Globalization was the theme for this image illustrating the cover of a July 4 issue

of *The New Yorker* magazine. Communist poster art was the inspiration for heroic workers machine-stitching the Stars and Stripes.

Opposite, bottom left:
Magazine cover
Pen and ink, digital
Niemann's expertise in combining pen, ink, and digital drawing allows a simple concept to shine through. This cover for another July 4 issue of *The New Yorker* says it all without having to fall back on a cover line or supplementary text.

Opposite, bottom right:
Magazine cover
Digital
An entirely digital artwork, this cover image for an April 15 issue of *The New Yorker*, the deadline for submitting US tax returns, represents the message graphically.

Left:
Book review
Pen and ink
An illustration for *The New York Times Book Review* accompanying a review of a book investigating how guns have become inseparable from the American character, this combines bold thinking with simple graphic art.

Below:
Book illustrations
Pen and ink
brush and ink (right)
In the book *100% EVIL* (Princeton Architectural Press), Niemann and Nicholas Blechman, designer, art director, and illustrator, visually dissect their own interpretations of evil. Working between projects and deadlines, and in late-night New York City bars, they created over 150 black-and-white drawings, including these two: Evil Pasta and Evil Shoe.

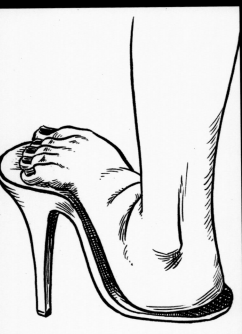

Below:
Book cover
Digital
The annual US showcase *American Illustration* commissioned this image for the cover of the 2001 publication. It signifies the relationship that illustration has with the American public: the warm embrace of the toothbrush bristles represent America and the toothpaste the discipline of illustration. An odd comparison certainly, but Niemann's creative thinking is generally anything but conventional.

Right:
Magazine cover
Pen and ink
A cover illustration for *The New Yorker*'s Style issue, focusing on Japanese fashion. Niemann once again draws influences from global art and design's rich visual history.

ファッション　特別号

Jeremyville

Jeremy (of Jeremyville) is based in Sydney, but has a studio in New York and is constantly in Europe for projects, exhibitions, and events. He understands the demands of mobile working twentieth-century style. "Yes, I travel a lot, and my laptop and sketchbook generally become my studio when I'm on the move. I find that the 18 hours I need to spend on planes to leave Sydney is a great way to come up with new ideas and to draw a lot," he explains.

But then Jeremy has always drawn a lot. While studying architecture at Sydney University he edited the student newspaper and, with "holes to fill" in the articles he was writing, started making illustrations. Spurred on by the success of his image-making, he approached the *Sydney Morning Herald*, Australia's leading newspaper, and began drawing and creating illustrations and strips. "That was the start of my illustration career, at age 19. A year later I opened my own studio," recalls Jeremy.

Despite a passion for working across a wide range of applications, from illustration and animation to toys and products, Jeremy's views on illustration sound quite traditional. "To me the ability to draw with a pencil or pen is a fundamental skill for anyone calling themselves an illustrator. I think the advent of lots of mediocre vector art has really demeaned the term 'illustrator.'"

Foldout poster
Ink, digital
This 30-panel foldout poster, The Nightmare, was produced for Kidrobot, creators and retailers of limited-edition art toys and apparel, as part of an 8in toy figure package. A limited palette of colors combined with Jeremyville's distinctive linework give this collectible poster a charming, yet quirky feel.

practice their craft constantly, and aim to offer something new and idiosyncratic— a style honed from "thousands of hours of drawing" that has evolved into something indicative of themselves as artists, and that is instantly recognizable. "Think Dr. Seuss, Dick Bruna, Schultz, Sendak, Hergé, Daniel Clowes," he states. "Anonymous, derivative illustrations are like extras in a movie—just noise to fill a background scene," he adds.

What drives Jeremy and his work? Is it all about drawing? "My main motivation is getting a concept across. The concept or idea is everything. What are you trying to say? An idea can manifest itself through many media, however, so I do a lot more than just illustration—I write and produce books, work on product design, design toys, paint large canvases, and work on animation, but when I illustrate, I'm an illustrator," he adds. What's the difference? "As an illustrator, you need to specialize for that moment and do what you are doing excellently, like a musician who can play various instruments. When you're on the piano you're not thinking about the guitar—you've chosen the piano because only the piano can tell that particular story. It's the same crossing creative media."

Sneakers
Mixed media
The classic Converse Chuck Taylor sneaker receives a radical redesign. Embossed leather gives this special Jeremyville collaboration with Converse a unique look and feel. Illustration meets fashion in this eye-catching edition of the famous shoe.

Book illustration
Mixed media
Jeremyville explored the vinyl designer toy phenomenon in his book *Vinyl Will Kill!*. Conducting interviews with 42 artists responsible for kick-starting an international movement, he spearheaded recognition of the genre.

Below right:
Designer toy
Mixed media
The Sketchel is a customized bag concept, devised by Jeremyville and Megan Mair; this designer toy, Sketchel Kid, is the mascot for the product. The Sketchel project has, so far, seen collaborations with over 800 international artists, each submitting designs for their own Sketchel.

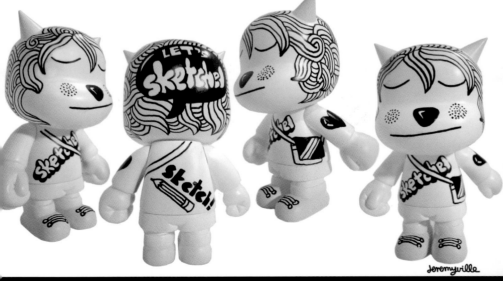

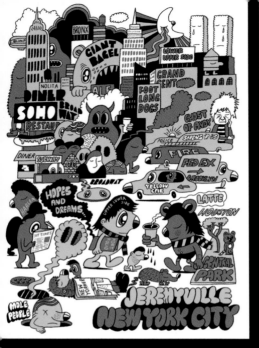

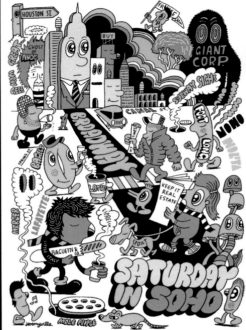

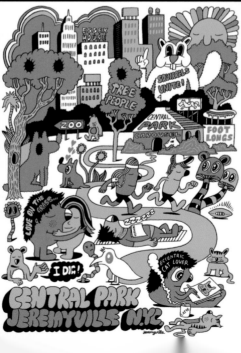

Screen prints
Screen print
Jeremyville's set of three limited-edition screen prints, printed on art-grade paper and inspired by New York City, were exhibited at The Showroom NYC, and hosted by Thunderdog Studios

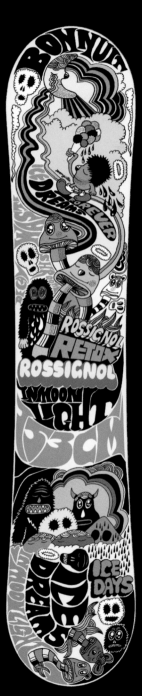
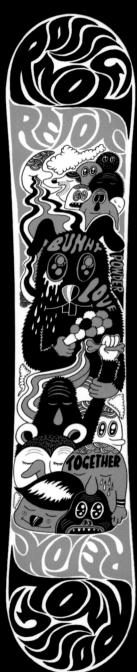
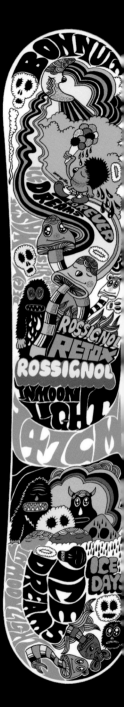

Snowboards
Pen, digital
This set of three snowboard designs for Rossignol was voted "most popular design" at a Japanese trade fair. Jeremyville's designs and illustrations continue to be embraced by a global audience. Rossignol also commissioned Jeremyville to create related apparel designs.

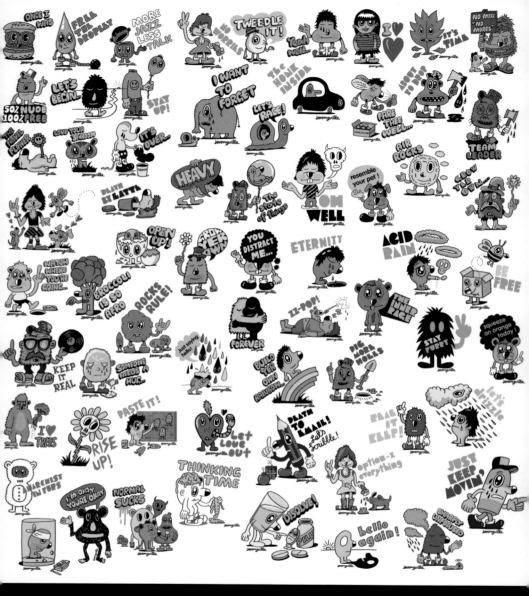

Characters
Pen, digital
Jeremyville has created characters for a number of companies and various applications, from cell-phone downloads to stationery, and from apparel to animation projects. Jeremyville uses the same process to begin every project, sketching with pen on paper before even booting up his computer.

Darth Vader helmet
Polymer paint
To celebrate the 30th anniversary of the original *Star Wars* movie, 80 international artists were invited to customize a life-size version of Darth Vader's helmet for a touring exhibition that launched in Los Angeles. Jeremyville's take on the brief was to look at the voices in Vader's head.

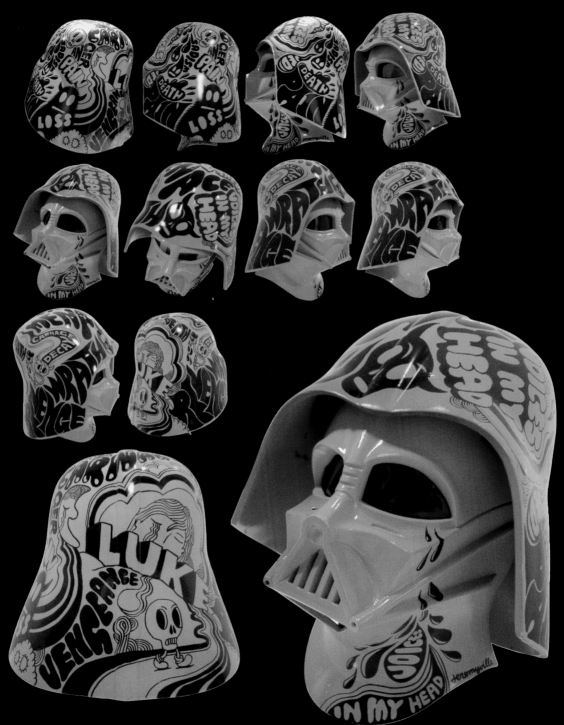

Gluekit

"Illustration is about communicating an idea through a graphic image," state the illustrators at Gluekit. "An illustration must express something because without an expressed idea or concept, it would simply be an image, and not an illustration." This simple statement captures the essence of Gluekit and their raison d'être.

Gluekit have spent time considering the discipline of illustration and their craft as illustrators. Christopher Sleboda, who set up the studio on completing his MFA in Design at Yale in 2002, was joined by Kathleen Burns, also a Yale student, in 2006. Gluekit is about much more than fitting into the existing fashions in image-making—their mission is "to create smart, intelligent, and, when appropriate, beautiful images that communicate a particular message."

A revised version of the principle "form follows function," this isn't a new concept, yet it still sounds refreshing, especially at a time when many consider illustration to be purely about decoration or ornamentation.

There is an honesty in Gluekit's work, and in its work ethic too. Their visual solutions to client problems span the spectrum from "concrete" right through to "impressionistic" messages. Gluekit is an upbeat studio, with a web presence that can best be described as quirky, and a body of work that remains resolutely optimistic. In Sleboda's words they "aim to create positive and sincere image-making. That really is a focus for us, as a kind of counter to the creep of cynicism, skepticism, and apathy."

And why the name Gluekit? It references the cut-and-paste of traditional collage, yet also acts, as Sleboda explains, "to suggest the various approaches we take, as part of a larger kit of components, which can be added to and reconfigured as necessary. We're very interested in fragmentation and reconstitution, in extracting and reformulating imagery, in exploring the intersection of hand-drawn and computer manipulated images, and transforming pieces into a unified whole. We like to think there's something kaleidoscopic and interconnecting in our body of work and the various tangents we've explored."

Magazine feature
Digital
Fire, police, and emergency workers involved in simulation exercises in New York City in preparation for potential terrorist acts was the subject of this illustration. This image for *New York* magazine draws inspiration from collage, comic books, and pop art to emphasize the reenactment of terror, creating a scene of formulated chaos and confusion.

Left:
Magazine features
Photograph, digital
For two articles on the US housing market crisis, both for *BusinessWeek*, Gluekit looked to visual metaphors—upturned Monopoly houses and a fragile house of cards—to illustrate the volatile and unstable real-estate market of the early 2000s. Their visually arresting and powerful graphic images communicate succinct messages.

Right:
Music reviews
Mixed media, digital
Gluekit's illustrations for the US music magazine *Stereotype* allow them to experiment with techniques and formats. Bold, graphic approaches typify their work. The mirroring of William Shatner and Lou Reed suggests a similarity in the style of Shatner's recent release and Reed's work, while Dizzee Rascal's "wall of sound" is visually expressed.

Below left:
Newspaper feature
Spray paint, mixed media, digital
For an article in the *Boston Globe* about how the city's annual marathon was almost canceled due to bad weather, Gluekit created an arresting image that captured the dramatic, stormy conditions using photographic elements, icons, and graphic textures.

Below:
Event poster
Mixed media, digital
This poster was designed to promote a lecture about illustration by Ramón Luna, better known as a graphic designer and photographer, at Yale University School of Art. Gluekit incorporated elements of Luna's presentation, such as magical realism, surrealism, and image representation using silhouettes, hand-drawn elements, and negative and positive space.

Left:
Event postcards
Spray paint, pen and ink, screen print
Gluekit created this set of three perforated postcards for the AIGA (American Institute of Graphic Arts) New York Chapter's Small Talks–a series of lectures by prominent designers. While each card highlights a specific designer's work, they all bleed fluidly into one another to emphasize the overlapping nature of graphic arts, and of this series of talks.

Below:
Indie-rock ringtones
Digital, spray paint
This illustration exploring the growing popularity of indie-rock ringtones, accompanied an article in *GQ* magazine. It was created using Photoshop and Illustrator, and includes scans of spray-painted elements.

Left:
Magazine feature
Screen print, digital
This spot illustration for *Portfolio* magazine accompanied an article about reckless CEOs who walk away from their businesses unscathed following economic troubles.

Peepshow

What is Peepshow? Company or studio, collective or agency? None of these describe what Peepshow is really about. Its 12 members refer to the studio space as the HQ or the Mini Empire. The studio itself is a custom-built space with matching desks, central meeting table, accounting area, and space for Peepshow stock, sold via its website. Peepshow has created a diverse product range including cards, prints, bags, posters, and T-shirts. But Peepshow is about so much more than just a physical space. The group also exhibits work in galleries, shops, and agencies, and produces its own regular printed publication in addition to its distinctive e-mail and web updates.

"Peepshow was founded as a way of collectively promoting our work, sharing clients, and staying in touch," explains founding member Miles Donovan. "Most members graduated from the BA Illustration course at the University of Brighton [UK], in 1998, and the launch of Peepshow has led to collaborative projects in art direction, styling, animation, design, and illustration for a range of clients including Nike, Toyota, Coca-Cola, and Diesel."

From support group to successful outfit, Peepshow has bucked trends and resisted stereotypes while constantly adding to its expertise by taking on new challenges. "Peepshow was set up after several of us worked with illustrator Graham Rawle on his Hi-Life installation for Expo 2000 in Germany—a life-size supermarket seen by more than 40 million visitors," continues Donovan. "After that we realized we could have a go at whatever was thrown our way."

Of course, specific commissions and projects come into Peepshow for individual attention, each member being a highly successful illustrator in his or her own right, but it is the diversity of collaborative projects that offers the most potential for stepping outside the traditional avenues for contemporary illustration. "Animation is certainly the most challenging of the collaborative work we do," admits Donovan. "Despite a few projects under our belts, it is still relatively new territory for us, so there is always lots to learn. Three-dimensional installations are another great favorite— getting to make giant things from cardboard and wood certainly beats sitting behind a desk all day."

Is there such a thing as a normal day at Peepshow HQ? "It changes constantly depending on what we are working on at the time. There are a lot of working weekends and late nights, we're constantly running around town for meetings, and often sat mastering animation work. No two days are alike—the only constant is mass tea consumption."

Spencer Wilson:
Personal work
Digital
This self-initiated image, created as a limited-edition giclée print for Peepshow's online shop, marked a new direction in Wilson's work.

Christmas animation
Mixed media, digital
The Peepshow team pooled
its illustration and animation
skills to create this delightful
Christmas e-card.

ゴジラ

がめんどくさい
な～と言った

**Elliot Thoburn:
Personal work
Pen, digital**

Gojira is one of Elliot Thoburn's personal pieces created as a limited-edition giclée print for Peepshow's online store. Without a client, Thoburn was able to explore themes and interests that inspired him, but the outlet of the Peepshow store gave him creative freedom with a potential customer base.

**Chrissie Macdonald: Album cover
Mixed media, photograph**

For the Kate Nash album *Made of Bricks*, Chrissie Macdonald created and photographed, with John Short, a series of small sets of a house and the rooms within. Nash's musical influences were the inspiration: featured elements within the rooms relate to lyrics from songs on the album. Macdonald works in 3D, often creating sets composed of elements she has previously photographed before rephotographing them in situ to create a new scene.

**Left: Jenny Bowers:
Fashion catalog
Pen, digital**
Pattern alone makes up
this image of two legs for
Howies clothing catalog.

**Right, top and bottom:
Lucy Vigrass: Exhibition
pieces
Mixed media, digital**
For Peepshow exhibition
Many Hands Make Light
Work, held at London's
Concrete Hermit gallery,
Lucy Vigrass created works
based on objects such as
buttons, stamps, and children's
building kits found on eBay.

**Below left: Elliot Thoburn:
Book cover
Pen, digital**
For the cover of *Notion*
magazine's *Hipster Handbook*
Vol 2, Thoburn created this
image of catwalk chaos, with
each and every character
unique and believable.

> 'Green thinking now is as much about personal quality of life as the quality of the environment'

> 'If a company takes an ethical standpoint it had better make sure it is ethical'

Antenna Credits

COMPILED BY THE FUTURE LABORATORY

Editor In Chief:
Martin Raymond

Creative Director:
Chris Sanderson

Editor:
Kate Franklin

Travel editor:
Alex Cunningham

CITY CORRESPONDENTS

Claire Adler: *London*, Zeynep Arhon Apak: *Istanbul*, Mady Arben-Salsorg: *Copenhagen*, Nina de Man: *Antwerp* Nicole Fall: *Tokyo*, Phil Gresman: *Beijing*, Claire Hyland: *New York*, Sara Kleve: *Barcelona*, Vernevi Leirena and Anna Mralanen: *Helsinki*, Lourences Bustani, Camila Pira & Ariella Sigre: *Sao Paulo*, Rinke Tjeplema: *Amsterdam*

ADDITIONAL RESEARCH

Priyanka Karne, Sarah Robia & Martin Farrington

ART DIRECTION & DESIGN

Benjamin Alder
www.22greenwineclocker.com
& Alex Cunningham
Assisted by Nichole Henuigan

The Future Laboratory, Studio 2, 181 Cannon Street Road, London E1 2LX, United Kingdom
T: + 44 20 7791 2020 F: + 44 20 7791 2021

viewpoint@thefuturelaboratory.com
www.thefuturelaboratory.com/viewpoint

Getting Greener

Saving the planet used to be a job for the beards-and-sandals brigade, but a new generation of right-of-centre consumers are re-writing the rules of how to be green.

Illustrations by Jenny Bowers, jenny@jennybowers.org.uk

Left and below:
Andrew Rae:
Personal work
Pen, pencil, digital
Microsoft funded Rae
to create personal works
on the theme of machines
and robots. These three
drawings represent only
a tiny fraction of the output.

Vault49 are at a turning point as an
Illustration studio, following a prolific
output of commercial work since leaving
their London roots for New York City
in 2004. Almost engulfed by their own
success, Vault49 have more than just
influenced a trend; they have been emulated
and imitated to the extent that they have
made a conscious decision to go back to
their roots. "It seems to us," explains John
Glasgow, one half of the duo, "that imitation
is rife in the industry. Increasingly, less
imaginative illustrators are trying to make
a living from another's success, and to
this end, we are aware that much of our
established portfolio has been diluted."

Staying ahead of the curve while
capitalizing creatively and commercially
on a body of work isn't an easy exercise.
"We do believe," continues Glasgow,
"that the most creative illustrators, with
an evolving approach to their work, are
less affected by the ebbs and flows in the
commissioning sector. There has always
been an enormous market for those
among the best in the field, regardless
of the economic climate. We work hard
to ensure Vault49 are in this group."

John Glasgow and Jonathan Kenyon
met while studying in London, graduating
with degrees in Graphic and Media Design
into an already saturated market. What
singled out Vault49 at the time was its
uncompromising use of illustration as
a method of visual expression. "Illustration
is the basis and starting point from which
we express our ideas, and is often the point
from which many other graphic forms grow
and develop for us, including typography,

motion graphics, editorial design, and other
creative disciplines. We wear many different
creative hats, combining a variety of skills
in our work on a daily basis."

With an impressive portfolio of work for
some of the biggest global brands, how are
Vault49 keeping ahead of the competition?
"The future for Vault49," Glasgow maintains,
"involves including an element of our past,
a partial return to craft-based skills. We
believe our original approach to innovation
and creativity, through screen printing and
other manual processes, was evident in the

work we created before we left our old print studio behind in the move to New York."

Vault49 have returned to their love of print with the introduction of a Vault48 portfolio. They've taken time away from commercial projects and the allure of the digital to reengage with the craft of print-making. Glasgow explains, "We want to make sure that, moving forward, our audience have the tactile and sensual experience of our work that was evident when we graduated from college, wheat

pasting (fly posting) screen prints and creating handmade print packages that flooded rooms with aromas of ink and hard work." Vault49's creative future is dependent on their creative past— from analog to digital, and back again.

Branding
Pen, photography, digital
QV Village, a shopping precinct in central Melbourne including business and living

spaces, required illustrated branding. Vault49's solution, with its fashion-inspired, decorative images, provided a strong visual identity.

Left and below:
Fashion graphics
Pen, pencil, digital
Vault49 designed and
art-directed a range of
graphics and illustrations
for fashion company Artful
Dodger. Complex, decorative
forms, incorporating hand-
drawn and photographic
elements, lend the Vault49
aesthetic to the brand.

Right:
Magazine promotion
Pen, photography, digital
Canadian fashion magazine
Orange Life commissioned
Vault49 to create a series of
images to showcase fashion
accessories. With photography
by Michael Creagh, the team
mixed hand-drawn elements,
decorative patterns, and
organic shapes.

All images:
Exhibition pieces
Screen print
In a bid to create work following new stylistic directions, Vault48 was created. This small print studio allowed Vault49 members John Glasgow and Jonathan Kenyon the scope to explore and experiment, away from commercial constraints and expectations, and to produce new work for their exhibition Secrets of the Beehive.

Product launch
Pen, digital
These two images are part of
a set created for the Samsung
Soul Phone launch in the US.
Vault49 began by investigating
meanings of soul—the broad

McFaul

The absence of a big-city address has done nothing to hold back McFaul, a multidisciplinary design and illustration boutique, from creating award-winning work for a cast of global clients. Recent projects include store refits for Carhartt, promotional illustrations for Nike Air Jordan, restyling the Liverpool John Lennon Airport, and a series of Havaianas murals across Manhattan. McFaul has had a busy period just a few short years since the studio's inception.

McFaul is the brainchild of John McFaul, an accomplished illustrator with an impressive back catalog of solo work. McFaul saw an opportunity to expand his repertoire by expanding his studio, growing his one-man outfit slowly from one to two and then four, before expanding to his current team of six designers/illustrators. "We have about 25 years of experience between us, and our expertise covers painting, drawing, screen printing, graphic design, street art, graffiti, animation, and, of course, illustration," he explains. "To us illustration is imagery, design, movies, objects, buildings … there are no boundaries for McFaul."

Modeling his venture on the ethos of a design company rather than an illustration collective or studio has enabled McFaul to take on and tackle projects that would traditionally have fallen short of the remit of the solo illustrator. The model also keeps McFaul firmly in the driving seat—he holds creative control in his hands and has a direct line to the client. "Each project we take on has to push us and the client. We don't want to put out the same piece of work for a new client, we like to evolve. We really enjoy working on projects that push us to

do something new, the ones that have an open brief and let us bring as many ideas to the table as possible. That always results in a fresh body of work."

Inspired by an endless stream of visual ephemera, McFaul claims that anything and everything has potential to motivate the team's work, from Japanese tattoos to underground comics … to breakfast cereals—many of the studio's creative brainstorming sessions take place over a breakfast bowl. "We research each project independently," he continues. "We enjoy the process of discussion and deliberation over exactly what direction to take, ensuring that our decisions are informed and not arbitrary—never purely aesthetic." So, what drives the final solutions? "We want to make beautiful work, but suitably beautiful

already to their name, and nominations
pending for others, it is clear that McFaul's
design philosophy has played an active
role in helping it earn its stripes.

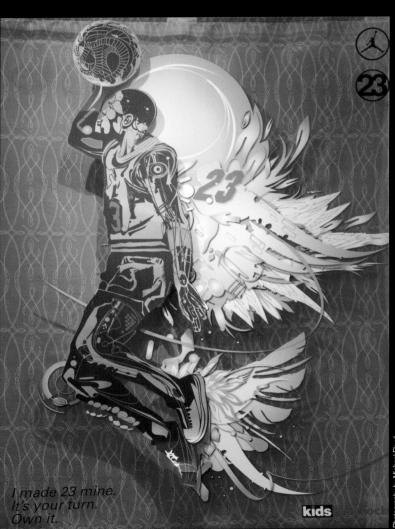

In-store graphics
Mixed media, digital
To celebrate 23 years
since the launch of the first
Nike Air Jordan shoe (Michael
Jordan's shirt number is also
23), and the launch of the
new Air Jordan XX3, Nike
commissioned McFaul to
create in-store graphics for
the US and UK Footlocker
stores. Creating intricate,
layered illustrations that
used printed cardboard
and window vinyl, McFaul
explored ideas around
Jordan's technical ability,
translating his athletic form
into a robotic version of the
basketball player.

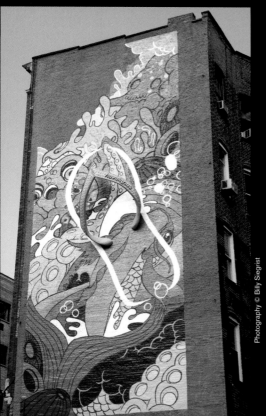

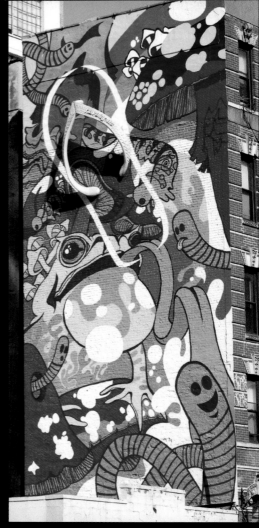

Promotional murals
Paint
Three key Manhattan
locations were used by
McFaul for BBDO to
create huge, colorful murals
to promote a new range of
Havaianas flip-flops. The brief
was to keep the images lively,
fun, and summery.

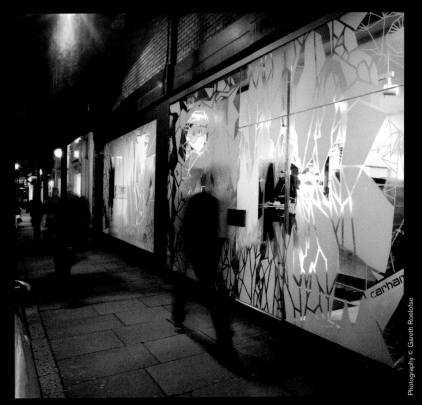

Store revamp
Mixed media

McFaul, commissioned by Carhartt to revamp both the interior and exterior of their flagship store in London, worked to a self-set theme of "ice world." Semitransparent vinyl was applied not only to the front of the store, to mirrors, and to changing-room doors, it was also used as wallpaper in a 56-hour marathon refit. The project included a set of limited-edition giclée prints on Somerset Fine Art paper.

Photography © Gareth Roelofse

Photography © Gareth Roelofse

Photography © Gareth Roelofse

Photography © Gareth Roelofse

All images:
Airport graphics
Mixed media
McFaul, working with
Broome Jenkins, spent
a full year on a project to
transform Liverpool John
Lennon Airport for Liverpool's
year as City of Culture
in 2008. Using 350m
(c. 1,150ft) of continuous
vinyl graphics, they wrapped
the 20 columns in Baggage
Reclaim and seven airside
buses. The meticulously
designed, illustrated, and
planned revamp gave
a stunning overall effect.

:phunk studio

:phunk studio was formed in 1996, two years after members Jackson and Alvin Tan, Melvin Chee, and William Chan met while studying at LASALLE College of the Arts in Singapore. The graphic design/illustration group was a means of breaking away from the restrictions of academic life—the four were not inspired by design companies or studios, but by rock stars and rock bands. "We were just teenagers," recalls Chan. "Our priority wasn't being designers, but partying. We found the idea of being rock stars attractive, so we merged the two and called ourselves a visual band." :phunk studio was launched as a T-shirt company, but turned to design and illustration after predicted sales failed to emerge. Following this change it quickly amassed an impressive client list spanning a range of applications across almost every aspect of communication design and illustration.

There are very few projects that :phunk have not turned their hands to, from fashion garments to designer objects—skateboards, mugs, bikes, vinyl figures, and bags—and design for print and screen. Their work has reached a global audience. "We get bored very easily. We like to explore, express, and communicate through different media," explains Chan. "We aim to blur the lines between art and design, creativity and commerce, craft and technology, east and west, control and chaos, love and hate, friendship and partnership, audio and visual." Quite some mission statement, yet this is no throwaway comment—:phunk explore many of these issues to great effect through their commercial and self-initiated projects.

Based in Singapore, :phunk readily embraces a culture that looks actively to both East and West. Situated in a place described as one of the world's cleanest cities, :phunk have made their mark by creating subversive imagery, perhaps as a backlash to their immediate environment. Their tongues, however, are firmly in their cheeks. They claim that the driving force for their work is less political and more rock and roll. "You've just got to always have fun in what you do," says Chan, and the fun shows no sign of letting up for this four-piece studio.

Top right: Exhibition piece
Screen print
Tiger Beer invited :phunk studio to be part of their Dublin show, Translate. Electricity is a 4 x 2m (c. 13 x 6½ft) illustration screen-printed onto canvas. It depicts an imaginary city that embraces the spirit of globalization–the meeting of different minds and cultures. Drawing upon their travels to New York, Berlin, London, Tokyo, Hong Kong, Beijing, Shanghai, and many other cities for inspiration, Electricity is a vision of a global city, where diversity is celebrated and there is no East or West.

Right: Exhibition mural
Mixed media
For an exhibition in New York, :phunk created a 12-panel mural of custom-designed "canvases" made from corrugated cardboard boxes. The theme of a dysfunctional and apocalyptic city, with a mix of heaven, earth, and hell, was the inspiration for the piece, which was created using vector graphics and screen-printed onto the card.

Bottom right:
Personal work
Digital
In this long-term, self-initiated project, :phunk studio explore an imaginary universe. This multimedia collection of artworks illustrates concepts and ideas concerned with "universal truth" and the symbolic relationship between the individual and his/her own universe in an age of globalization and technological advance. Universality is infused with :phunk's own visual language and wit.

Artist-in-residence works
Pencil, digital

Treasure of Social Pleasures
is a body of work created by
Phunk studio as part of an
artist-in-residence program
at Zouk, a nightclub based
in Singapore. Hand-drawn in
pencil before being imported
into Photoshop, the images
offer a dark glimpse of
a magical world.

eBoy

Could it be that the pre-design lives of eBoy's three founding members have contributed to the group's much copied, but never equalled, complex digital vision? Svend Smital trained as a bricklayer before studying at the Berlin Academy of Art; Steffen Sauerteig worked as an electrician, going on to build sets for East German television before studying at the College of Fine Art, also in Berlin; and Kai Vermehr released two LPs as Kabbahri before studying at the Folkswangschule in Essen. A bricklayer, an electrician, and a musician are responsible for the construction of seemingly endless digital worlds, built from their own unique digital visual language, laying each brick and wiring each lightbulb pixel by pixel.

eBoy's incredibly rich body of work spans more than 11 years. The eBoy.com domain was acquired in 1997, when the web was a very different place from today. The web allows eBoy to work in three different locations: Vermehr and Sauerteig work from their home offices, while Smital runs a studio, where the three meet up from time to time. "A normal day for us starts around 10.00am, with video chatting about new e-mail requests and projects. The rest of the day means working or organizing stuff. We usually stop around 1.00am."

Creating complex and detailed digital worlds is a time-consuming occupation. eBoy aren't about to start taking it easy. "We'd love to work on an MMORPG at some point, be able to actually build our worlds to explore," they state matter-of-factly. MMORPG? A massively multiplayer online role-playing game is basically a genre of role-playing games in which a large number of players interact with each other in a virtual world. "It would be something like *World of Warcraft,*" often criticized for its addictive qualities, "but urban science fiction" they add.

Long days and nights in front of the screen remain a constant fixture for eBoy. There is really no quick-fix solution to this problem: the work is visually and technically complex. "The best thing about what we do is being creative, and the worst thing is sitting all day." It is a far cry from the real-world, real-time construction site of bricklayers and electricians.

Promotional poster
Digital
eBoy's work for the Honda Icon Museum won a Gold Award from the Japan Internet Advertising Association (JIAA). This postcard image is just one example of a range of work eBoy has created for the brand.

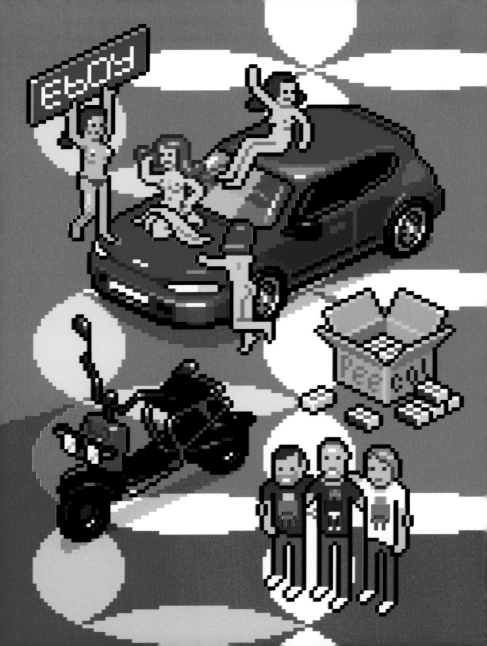

Poster series
Digital
An ongoing project, eBoy
are constantly adding major
world cities to its expanding
range of self-initiated posters—
Pixorama. In addition to
London, New York, and
Oslo (all featured), Berlin,
Singapore, Venice, Baltimore,
Dublin, Los Angeles, Cologne,
and Tokyo have all been given
the eBoy treatment.

Top right:
Book illustration
Digital
This graveyard of "dead" political parties, real and imagined, demonstrates eBoy's ability to mix conceptual thinking with their trademark digital aesthetic. Humor and political statement vie for attention in this illustration.

Right:
Poster
Digital
Sold through their own online store, eBoy's poster of buildings acts as a back-catalog of previously drawn and utilized architecture.

Kapitza

Kapitza might be located in urban east London, but the two sisters hail from the German countryside, and both locations inspire their output. "We find inspiration in the everyday and the mundane, like the commute to our studio," explains Nicole Kapitza, the elder of the quiet and thoughtful duo. "Growing up in the countryside and going home frequently means that a lot of our work is also inspired by nature," she continues.

Whether working with images of inhabitants of the city or with natural forms—flowers and plants—Kapitza have a knack of exploring and exploiting simple forms. "Illustration can either highlight what is there or create something out of nothing," offers Petra, the younger sibling. "It can make nonvisual things visual, like events, actions, or processes." Kapitza display an almost scientific rationale in describing their working methods. "The way we work has to do with filtering out what is of interest to us. We distill the natural world and place emphasis on certain aspects of reality," continues Nicole.

Having the luxury of initiating much of their own output rather than working to any client restrictions, they begin a project with a self-directed brief before taking the results into the commercial arena by selling their designs as "fonts" or vinyl sticker sets through their own online store. "Our favorite projects," explain the sisters, "are the flower illustrations, people, and pattern fonts. We enjoy the challenge of self-directed projects.

These projects allow us to investigate, to get deeper and deeper, to develop and push a theme until we are satisfied."

But the Kapitzas are not only about working to please themselves—the sisters have a growing list of clients. Recent commissions include large-scale artworks for the University of Bedfordshire, UK, and the Void Gallery in Derry, Ireland. Despite never having submitted projects for any awards, they have picked up plenty of recognition in the international design press, *Eye*, *Idea*, *Grafik*, *Page*, *Novum*, *Creative Review*, *Computer Arts*, *How*, *Digital Arts*, *Digit*, and *Communication Arts* being just a selection of the publications that have featured their work. It is clear that Kapitza have quietly, and quite cleverly, arrived.

Above:
Personal work
Digital
Kapitza work on as many
self-initiated projects as
they do commissioned.
This abstract image of
clouds is typical of its
approach to using graphic
filtering to create patterns
inspired by natural forms.

Right:
Pattern font
Digital
Basic, a self-initiated project,
provides endless possibilities.
As a large number of pattern
fonts, Basic allows the user
to create an infinite number
of graphic patterns and
animations. The fonts are
all based on geometric
shapes—circles, triangles,
stripes—in various forms
and set at various angles and
sizes. By simply changing the
font, one pattern can easily
be transformed into another.

Left, top and bottom:
Vector illustration
collection
Digital
Taking inspiration from an eighteenth-century herbarium, Kapitza set out to explore the fundamental structures that shape nature. In abstracting form and stylizing geometry, this aesthetic treatment was a departure from their earlier flower studies. The results are foliage, leaves, and wildflower illustrations with a magical, enchanting quality that seems removed from everyday life.

Top right:
Vector collection
Digital
We Love Nature, a collection of digital illustration sets—blooms, stems, leaves, and flowers—contains 164 illustrations. The illustrations are based on photographs taken over a period of time, in different locations, which are then traced and scanned.

Bottom right:
Limited-edition print
Digital
A self-initiated project sold as a limited edition in Kapitza's own online store, this map is composed of colorful vector illustrations.

Above, left and right:
Picture font
Photograph, digital
Kapitza's silhouette fonts
observe, record, and catalog
the ever-changing nature
of inner-city populations.
Inspired by the diverse and
dynamic neighborhoods near
their studio in East London,
an area with populations
spanning a wide range of
classes, ages, and ethnic
backgrounds, they venture
out to take photographs.
From these they have
created vibrant sets of people
silhouettes with site-specific
names like Liverpool Street,
Victoria Park, Brick Lane,
and Dalston. The silhouettes
document a moment in time
in these rapidly changing
areas of East London. Though
stark and simple, the images
make complex connections
between people and places.
Kapitza intend to extend this
ongoing project to other
areas: rural and urban, local,
national, and international.

Right:
Limited-edition print
Photograph, digital
Generation Z is the first
generation to live its entire
life with digital technologies.
A self-initiated project, this
is another of the designs sold
as a limited-edition print on
Kapitza's online store.

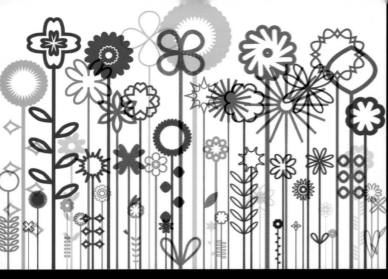

**Picture font and
vector illustration**
Digital

Pop contains 320 graphic
elements in four weights
(Pop10, Pop20, Pop30,
and Pop40). When repeated,
each Pop element creates
a unique pattern. Every Pop
element and weight can be
combined with any other to
create an unlimited number
of patterns. Pop was inspired
by the bold, colorful fashion
textiles of the 1960s and
1970s, and particularly
by their graphic simplicity.
Pop Flowers grew from
Pop when Kapitza realized
that, when combined, the
characters began to represent
blooms. "We just added
stems and leaves to create
these lovely flowers," the
sisters explain.

Left:
Vector graphics collection
Digital

Twirl is a set of 50 graphic
twirl illustrations. These can
be used on their own, or
as building blocks to create
colorful, layered illustrations.

Mike Perry

Mike Perry is a morning person, getting up and into his Brooklyn studio, a short walk from his Crown Heights home, for 7.00am, generally getting a lot done before midday, but rarely leaving the studio before 7.00pm. "I often have times with a short attention span, so I end up working on lots of different projects throughout the day," explains Perry. "I am excited by life. I am inspired by everything," he enthuses. "I love being with friends and being inspired by their energy," he adds. "I start each project by trusting myself, and letting work happen. I'm inspired by my process. I love making piles of drawings and seeing the work build out of that pile."

Growing up in Kansas and Missouri, MidWest America, has left its mark on Perry—he feels like an outsider in New York. Studying at Minneapolis College of Art and Design (MCAD) in Minnesota, rather than in Manhattan, has given him a tougher attitude too: success wasn't a given. "I graduated MCAD in 2002, then moved to Philadelphia for a job as designer at Urban Outfitters, where I spent the next three years," recalls Perry. "I work as a designer and illustrator, but really consider myself a maker. I look at myself as someone who makes things happen, and I happen to make illustrations."

Making illustrations with a designer's sensibility gives Perry's work a sense of freedom that eludes many illustrators. He has a knack for creating works that convey the essence of himself as an artist, but without being fenced in by a style or a particular way of working. Perry's visual signature, while refreshingly unique, remains varied and resists classification. He is as happy hand-rendering type treatments as he is designing logos, creating intricate patterns, art directing fashion editorial spreads, making collages, or simply drawing and painting. "I try to approach each project as a problem to be solved," he states, "and if something needs to be a drawing I make a drawing; if it needs to be a collage I make a collage."

Perry, by his own admission, needs the inspiration of those around him. "I recently worked on a fashion story for *The New York Times Magazine* that was really stressful, but the process was very rich. The art director had lots of ideas and we really pushed each other to make a very special piece." Perry might share his Brooklyn studio with another designer/illustrator and a photographer, but many of his projects remain solo affairs. "I really like working with others; I love the interaction. The best thing about what I do is getting paid to make things, and the worst thing is working alone," he states. Illustration can be a lonely business. Perhaps this is the real reason that Perry prefers the title "maker" to "illustrator."

Limited-edition print
Screen print
Through his self-initiated projects, Perry explores ideas, themes, and concepts as well as drawing and printmaking techniques. These often reappear in commissioned projects or take on a life of their own as limited-edition prints such as this one, Shapes and Patterns.

Below:
T-shirt
Pen, pencil, digital
Perry was commissioned
by 2x4 to create spring
T-shirt designs. His abstract,
hand-drawn patterns and
vector shapes give his
designs movement and depth.

Below right:
Magazine feature
Pen
Perry's fascination with the
creation of new and imaginary
forms is evident in Optical-01,
one of a set of optical illusions,
hand-drawn in pen, for *Arkitip*.

Left and far left:
Personal works
Mixed media
Perry's ability to create a synergy between hand-rendered letterforms and hand-drawn imagery can be seen in both his commercial and noncommercial projects. So Much Grows in Brooklyn and Reached Over Found What I Was Looking For are both examples of Perry's increasing confidence to explore his own quirky interests within his artworks.

Left:
Logo/identity
Watercolor
This illustration, commissioned by Urban Outfitters, is based on Japanese-inspired waves, Egyptian pyramids, and Californian rainbows. Perry brings pattern, drawing, color, and letterforms together to create a global logo/identity.

Success is for the people at the precipice. The entrepreneurs, innovators, risk takers, and dreamers. We remind you to never stop thinking. Proactively seek out fresh answers. Find partners. Remember that you are only as smart as the people you surround yourself with. Seek out people who are smarter than yourself. Nurture them. Reward them. Because they are the future. Become cosmonauts of change. Move forward. Find your buzz. Remember that life is a continual uncovering. Most of all, discover the things that thrill you and do them. In the end, they are the only reason to get up in the morning. Thinktopia© is an idea engineering company dedicated to building communities around brands. We work in a variety of media, from designing brand futures to media development. Better thoughts through thinking. www.thinktopia.com

THIS IS NO ORDINARY CITY. THIS CITY OF OURS. THIS IS THE LAND OF SKYSCRAPERS AND YELLOW-CABS. THE CAPITAL OF EVERYTHING This is the Place songs ARE Written ABOUT, MOVIES ARE SET, AND Literature EXPLORES. THIS IS THE HIP-HOP SPOT, THE HEART OF BEBOP, PUNK AND SOUL. THE SYNONYM OF ROCK AND ROLL. THIS IS FIVE CITIES IN ONE: BROOKLYN, THE BRONX, QUEENS, STATEN ISLAND, MANHATTAN. HOME TO EVERY COLOR, CULTURE, FASHION AND FLAVOR YOU CAN THINK OF. THIS IS KNISHES, KEBABS, PIZZA, PATÉ, SATAY, AND ALL THE BEST THE REST OF THIS WORLD HAS TO OFFER. THIS IS WHERE THE BALL DROPS AND CURTAINS RISE. THIS IS BROADWAY, OFF-BROADWAY, OFF-OFF-BROADWAY, BEYOND BROADWAY. THIS IS PEOPLE WATCHING, CELEBRITY SIGHTINGS AND SAMPLE SALE PRICES ON THE CUTTING EDGE OF STYLE. THIS IS RAW, SOPHISTICATED, BEAUTIFUL, AVANT-GARDE. THIS IS ENERGY. SO EXHILARATING YOU CAN FEEL IT IN YOUR SOUL. THIS IS ALL OF THE ABOVE, ALL AT THE SAME TIME.

This is New York City
nycvisit.com

MIKE PERRY

MAKI

The founding partners of MAKI, Matthijis Maat and Kim Smits, met while studying at the Art Academy in Groningen, the Netherlands. The studio name, which combines the first two letters of Matthijis and Kim, also references a type of lemur famous for its great communication skills.

On graduating in 2003, Maat as a graphic designer and Smits as an illustrator, the pair started working together. "Working as a duo is really motivating for us," explains Maat. "We work from our home and have a lot of fun in what we do, and it shows in our work." This might sound like an understatement when one views their body of work. MAKI projects are infected with humor, from seemingly inconsequential characters to throwaway sayings and thoughts.

While working in illustration has given the duo some of the creative freedom they crave, they recognize the need to extend their offering. "We don't just focus on illustration," continues Maat, "we combine this with graphic design. We're pretty flexible. For an illustrator these days, it is certainly good to know a thing or two about design issues too." Looking at MAKI's portfolio, it is clear that the combination of designer and illustrator works well in the partnership. Maat's hard graphic edges are smoothed by Smits' fluid, flexible drawing style, and in return, her illustrations are given form and context by the graphic framework he creates.

"The things we create together are better than those we create separately," announces Maat. "When we disagree it's because a solution doesn't work; when we agree, we know it does, so if one of us is unhappy with a piece, it usually means

something is wrong with it. We'll just work on it some more until we both approve. This approach brings us to a level that we wouldn't reach on our own." Whether it takes two minds and four hands to create each and every image is debatable, but built-in quality control and an ethos of fun have ensured that MAKI's work continues to export globally from their hometown of Groningen.

Above:
Invitation
Mixed media
MAKI created a folding invitation and flyer for a Pecha Kucha night. On these nights guest presenters are permitted to show a limited number of images for a strictly limited period—normally just 10 or 20 seconds. This particular event, organized by Platform Gras in the Netherlands, and held in a former prison, is "dark on the outside, but inside it's buzzing," explains MAKI.

Café graphics, identity, and branding
Mixed media

For Naked Lunch, a sandwich and coffee bar in Vienna, Austria, MAKI created the café's visual identity and branding as well as external graphic panels. Happy characters and foodstuffs exist in harmony across two montages that illustrate the ethos and character of the café perfectly.

Above:
Event poster
Mixed media
For the Day of Architecture
in MAKI's hometown of
Groningen, the Netherlands,
Maat and Smits designed and
illustrated this poster so that,
when hung side by side with
other copies of the poster,
a larger cityscape is created,
with the buildings and
patterns perfectly linked.

Above:
Festival poster
Pen, marker, digital
This striking poster was
created to advertise a live
event for student bands.
The quirky characters, bold
colors, and patterns represent
the energy MAKI felt typified
the festival.

Right:
T-shirt
Mixed media

**Left.
Cabaret poster
Pen, digital**

Using a restricted color palette allowed MAKI to pack this poster with energetic drawings without overwhelming the viewer. The muted colors also let the white text stand out clearly and catch the viewer's eye. The sense of fun and craziness it creates capture the spirit of the festival.

**Far left and bottom:
T-shirt and wallet
Mixed media**

MAKI created this Goldrush Rainbow T-Shirt design and Bear Camp wallet design for Poketo!. Surreal ideas and humor live large in MAKI's world.

**Right:
Poster series
Pen, photograph, digital**

MAKI created this poster series, Daydreaming, for online site Design is Kinky, and regular design event Semi-Permanent Australia, using found photographs, ballpoint pen, and Photoshop. These images have a more contemplative quality than much of MAKI's other work.

Gary Taxali

Gary Taxali has won pretty much every illustration award going. His strategy is to maintain a healthy 50/50 balance between commercial and noncommercial projects. This drive and commitment to his own practice is apparent in his work. Witty ideas and a unique, memorable drawing style combine with effortless fluidity—this is a body of work that lives and breathes its creator's vision.

Based in Toronto, Canada, where he grew up after his parents emigrated from India when he was one, Taxali doesn't fit the usual mold. "I have two studios," he admits, "and I work in both. Some days are devoted to painting and screen printing; some days are devoted more to drawing and conceptualizing," he adds.

Quizzed about aspects of professional practice he has found most enjoyable and/or challenging in recent years, from editorial to music-related or fashion-centered illustration, Taxali is quick to respond. "Those labels are arcane because it doesn't matter who the client is. I don't discern between a magazine, illustrating a product for an ad agency, or creating album artwork for a record company. To make such divisions in illustration no longer applies. At least it doesn't for my work. If I don't have 100% control over creativity, then I kill the job," he adds swiftly.

Character set
Mixed media
These hand-drawn characters are part of Taxali's self-initiated project Wallop. Taxali's output isn't driven by style but by attitude, and a commitment to picture-making. He combines original thinking, excellent character development, and masterful linework.

VIKRAM HOW VIKRAM SEES HIMSELF

"Just then, the truth hit him - he would
be nothing more than last year's winner."

Gary Taxali's career began the moment he graduated from Ontario College of Art in 1991 and has gathered momentum ever since. What is his secret? "Rule 1: I create personal work every week," Taxali explains. "Rule 2: I don't do art director's ideas; rule 3: style shouldn't drive the pictures, the pictures should drive the style; and rule 4: illustration is not art, but all illustrators are artists," he ends provocatively.

Far left:
Exhibition piece
Mixed media
La Luz de Jesus Gallery in Los Angeles played host to Taxali's exhibition Chumpy's Night School. This image from that exhibition, Unfamous, takes a wry look at advertising characters that, while looking familiar, appear lonely and without purpose.

Below left:
Magazine feature
Mixed media
Taxali used found paper and mixed media to create Dynamite Stocks, an editorial illustration commissioned by *Esquire* magazine for its "Money" page.

Top:
Magazine feature
Mixed media
For *BLAB! Magazine*, Taxali created a set of surreal poker-playing characters, beautifully drawn and crafted using a limited color palette, each character depicted with a different hand-rendered letterform.

Left:
Wine label
Mixed media
Taxali designed this wine label for Bonny Doon Vineyard. Definitely not a traditional take on the wine label, it is typical Taxali in thinking and application.

TOTALLY REPUGNANT IMMENSELY APPETIZING

GARY TAXALI

The best books

If you require more than a catalog of the latest and greatest images, key books on illustration are relatively few and far between. Books that take a critical look at the discipline in any depth are rare.

History

Books that deal with aspects of the history of illustration include the excellent *Graphic Design: A Concise History* by Richard Hollis, and *The Thames & Hudson Dictionary of Graphic Design and Designers* by Alan Livingston. *Graphic Design TimeLine: A Century of Design Milestones* by Steven Heller and Elinor Pettit charts, as the title suggests, key events and dates of the last century. Another book that ends its investigation before the twenty-first century, *Illustrator's Sourcebook: 1850 to the Present Day*, by Nick and Tessa Souter, is a unique guide to the most well-known illustrators of that period, and their work.

For more recent historical and contextual studies, concentrating on the move from analog to digital working methods, three books cover the area well. *Commercial Illustration: Mixing Traditional Approaches and New Techniques* (previously in hardback as *Picture Perfect: Fusions of Illustration and Design*) by Ian Noble investigates the crossovers between graphic design and illustration, and how the computer has forged and fostered increasingly effective means of visual expression.

I'd be foolish not to mention two of my own books, so here they are. *Digital Illustration: A Master Class in Creative Image-Making* and *Secrets of Digital Illustration: A Master Class in Commercial Image-Making* offer recent historical perspectives and analysis of contemporary practice, along with profiles of and interviews with the world's most talented illustrators.

Theory

A few books look at the theoretical aspects of illustration practice in some detail. *The Education of an Illustrator* by Steven Heller and Marshall Arisman, while maintaining an American perspective on art and design education, covers aspects of illustration practice through a series of essays by 30 leading practitioners. Claiming to be "part manifesto, part instruction," this book investigates the tricky issue of the relationship the subject has with fine art.

Illustration: A Theoretical & Contextual Perspective by Alan Male sets out to investigate and explain the intellectual engagement the illustrator has with subject matter, problem-solving, and the art of visual communication. This book serves students of the subject well, despite being a touch dry, and does a good job of describing the discipline's component parts.

Mark Wigan's series of books are easy to read and offer an infectious enthusiasm for the subject. They cover many aspects of practice at breakneck speed. Take a look at each of the books in the Basics Illustration series: *Text and Image*, *Thinking Visually*, *Sequential Images*, and *Global Contexts*. All are musts for students, if only to view a perspective entirely different in form and presentation from Alan Male's.

Professional practice

There is an increasing number of books that offer professional advice for illustrators, but, and I would say this wouldn't I, the best book on contemporary practice is my own *The Fundamentals of Illustration*. Covering a myriad of subjects, this book explores ideas generation and the routes to visual problem-solving and communicating messages, effective research methodologies, techniques for self-promotion, portfolio presentation, essential analog and digital kit, production and legal advice, and studio setup.

Another useful book, *How to be an Illustrator* by Darrel Rees, owes much to Adrian Shaughnessy's *How to be a Graphic Designer, Without Losing Your Soul*, but does cover much of the day-to-day experiences of a working illustrator, albeit from an agent's perspective. Rees runs a successful illustration agency with offices in London and New York.

Technical advice

Books I refer to for technical advice as an illustrator include the following: *The Complete Guide to Digital Illustration* by Steve Caplin and Adam Banks, and *The Complete Guide to Digital Graphic Design* by Bob and Maggie Gordon. Both are useful books that rank alongside *The New Graphic Designer's Handbook* by Alastair Campbell (a book I first discovered as an illustration student myself) in terms of the technical expertise explained in jargon-free, easy-to-follow, bite-sized chunks. There are plenty of other books that cover digital skills for illustrators. Look for titles that best suit your needs, and, of course, as software upgrades arrive, keep an eye out for new titles and revised books to keep abreast of changes.

Illustrators

There are times when viewing illustrations, albeit out of their original context, for the pure enjoyment of looking at excellently composed and crafted artworks is enough. There is a wealth of material that fits this bill and all offer eye candy from the world's sweetest confectioners. Take a look at Angus Hyland's *Contemporary Illustration: The Picture Book*. Other books in this category include *Illusive: Contemporary Illustration and its Context* by R. Klanten, and *Illusive 2: Contemporary Illustration and its Context* by Hendrik Hellige, as well as *Illustration Now!* and *Illustration Now! Volume 2*, both edited by Julius Wiedemann, and *Clin d'Oeil: A New Look of Modern Illustration* by Adam Pointer (for which I wrote the introduction!).

Glossary

art director
The designer who has overall responsibility for the style, content, and appropriateness of the work as briefed.

collage
Derived from the French word *coller*, which means "to stick." Collage is a technique that involves sticking pieces of paper, photographs, and found images onto paper, card, or canvas in order to create a new form. Collage, initially developed in China around 200 BC, provided the inspiration for the early digital manipulation of images by graphic designers in the late 1980s.

collective
A group of illustrators and/ or designers, often multi-disciplinary, working together on an equal creative footing. A group partnership. Individual members may work on their own, or together with other members of the collective, on any given project.

commercial art
A term once used to describe the work of the graphic artist/ designer. Commissioned by a client, a commercial artist/ designer charges a fee for solving communication and design problems in response to a brief. Commercial art is sometimes viewed as inferior to fine art, the rationale being that working to a specified outcome diminishes the integrity of the work.

comic
A series of static, sequential images, often combined with text, arranged to relate a story.

creative director
Similar to an art director, creative director is a job title that is often applied to art directors operating at a more senior level, perhaps managing a number of design teams.

cultural commentator
Illustration has played a key role in reflecting contemporary society, being a vital reservoir of social and cultural history. In creating images that express a point of view across such fields as music, fashion, and literature, illustrators become cultural commentators.

design brief
The design brief tells the illustrator(s) what the client wants. It should provide them with all the information they need to meet the client's requirements. Most briefs focus on the results and outcomes of the design, and the objectives of the design project.

digital revolution
The massive change in the process of illustration, and in the methods of production, sending, and viewing illustration that occurred with the advent of digital media.

fine art
Art concerned primarily with the creation of beautiful objects rather than to fulfill a specific requirement.

freelance
To work without being employed by any one person or company.

graphic design
Very loosely, graphic design combines different elements, primarily text and images, to convey messages and information.

graphic novel
A fictional story presented in comic-strip form, and published as a book.

people's art
This phrase refers to the ready availability of illustration; access to it is not restricted to particular classes or occupations.

personal visual language
A distinct and recognizable style that is unique to the illustrator.

self-author
To create a work with no brief to work to and no required outcome other than that chosen by the creator. This is an increasingly popular choice among illustrators wishing to take greater control over the direction of their work.

style
A particular visual approach. Style is a contentious term. There are those who believe that an illustrator must stick to a specific style so that clients can be sure of the outcome before a commission is undertaken. The term is also often applied in relation to fashion and frivolity rather than visual problem-solving and communication.

visual communication
Communicating through image rather than word.

Index

Credits

Thanks must go to my editor, Lindy Dunlop at RotoVision. She relentlessly pursued me when so many others would have given up, of that I'm sure. In understanding the busy life of an academic, an illustrator, and a writer, Lindy worked solidly to ensure that this book saw the light of day.

Thanks to Oli Hydes for image sourcing, chasing release forms, going beyond the call of duty, and for being so darn dependable—also for understanding (as only a fellow illustrator can) that illustrators are not the most organized people in the world.

Thanks to all the contributors without whose talents you wouldn't be holding this book in your hands right now.

Thanks to all those who work with me at the University of Brighton, running the BA (Hons)/MDes courses in Graphic Design and Illustration, particularly Karen Norquay for space and support, Sarah Elliott for frontline defense, and Paul Burgess for helping me frame some of my most random thoughts.

Thanks to the many students of graphic design and illustration I have worked with over the past two decades—some of the very best practitioners today!

Thanks to the many people with whom I have had conversations about the discipline of illustration and why it matters.

Thanks to those people who have supported and encouraged me, and, on occasion, picked me up— you know who you are.

Thanks to my family—Lesley, Louie, Jake, and Felix—for being there throughout and keeping clear when my mood swings got a little too crazy… Thanks too to Ann and Matthew for a great start in life, even if it did have to be in Basingstoke.

RotoVision would like to thank Chris Mullen for his gracious help with providing images and background information for "A brief history."